FRESH PRINTS

FOR NANNY AND GRANDAD, A CONSTANT
SOURCE OF INSPIRATION AND LAUGHS.

FRESH PRINTS

25 EASY AND ENTICING PRINTING PROJECTS TO MAKE AT HOME

Christine Leech

Quadrille
PUBLISHING

Photography by Keiko Oikawa

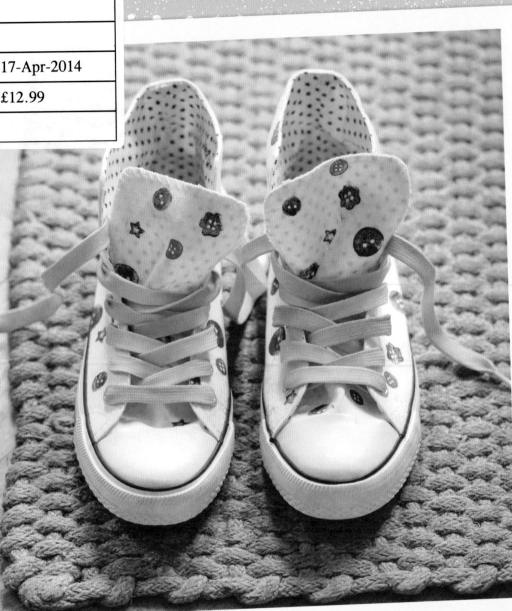

CONTENTS

Introduction 7
The printmaker's kit 8
Colour mixing 12
Printing top tips 14
Ink consistency 15
Making and using a
Lazy Lino template 16

PRINTING WITH FOUND OBJECTS
Botanical greetings cards 22
Atomic kitchen tea towels 26
Glittery giftwrap 30
Button boots 34
Feather cushion 36
Hiawatha T-shirt 40
Delicate doily bunting 42
Lacey casey 46
Ric rac scarf 48
Knitty natty cushion 52
Shimmering scales napkins 56

LAZY LINO PRINTS
Bow shoes 62
Nordic forest lampshade 64
Nordic forest bag 68
Owl family notebooks 70
Mrs Hare and family tote bag 74
Mrs Hare T-shirt 77
Mushroom mayhem cushion 78
Toadstool cushion 82
Bloomin' marvellous storage boxes 86
Rainy day brolly 90
Circus letter wooden postcards 94

OTHER PRINTING TECHNIQUES
Giant ginkgo leaf blind 100
Bleach beach towels 104
Which way? pencil case 108
Sunflower tablecloth 110

Templates 114
Resources 125
Index 126
Acknowledgements 128

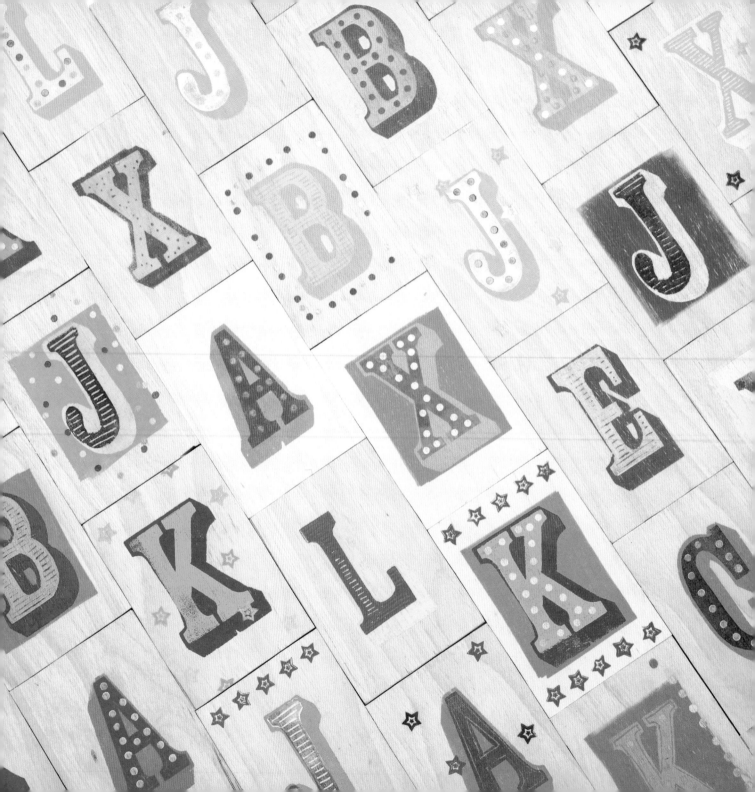

INTRODUCTION

When deciding where I was going to go to college, there were several factors I took into consideration: distance from home (not too far, not too close) and what the architecture of the buildings was like (old and crumbly good, modern and concrete bad). I remember visiting Bath (where I eventually went on to study illustration) and walking into the large printing block. There were two printing studios – one for screen printing (where I maybe spent three days in the three years I was there) and one for everything else – woodcuts, lino cuts, engravings, litho prints, mono prints and letterpress. The room smelt of turps, fresh ink and coffee and I felt instantly at home.

The majority of my final year show was made up of different forms of printing. Sadly, though, once I graduated, I lost access to the beautiful old presses and endless supplies of ink, my printing days came to an end. So imagine how excited (and slightly concerned) I was when asked to do a book on printing. How would I decide what types of printing to use in my projects? What materials and tools would be available to the home printer? Fortunately, I needn't have worried. Having made the initial decision that the book would focus on block printing where different objects are used as printing blocks, be they found objects, such as cookie cutters or leaves, or engraved blocks of wood or lino, the ideas for projects quickly started taking shape.

I still had a slight concern, a worry for my (and your) fingers. My hands were always covered in small cuts and blisters from the engraving tools I used when making my wood cuts at college and I wanted to avoid this for the book if I could. And I have! Most of the projects on the following pages are made using Safeprint foam sheets as the basis for the block.

This foam, which I have christened Lazy Lino, is a thin polystyrene sheet that can be cut with scissors and engraved with a pencil, giving all the detail of a wood cut but with much less risk to fingertips. It can be used on large-scale projects, such as the Mushroom Mayhem Cushion (see page 78), and on dainty intricate prints, such as the Mrs Hare and Family Tote Bag (see page 74). It takes a fraction of the time to make and if your engraving tool slips or you cut the wrong piece out, you haven't just wasted four days of work as it's super quick to make another block.

The projects that don't use Lazy Lino use things that are readily available and are probably in your house right now – potato mashers, ribbons, buttons and cookie cutters are all used as printing blocks. They create surprising repeat patterns, such as on the Atomic Kitchen Tea Towels and Button Boots (see pages 26 and 34). You don't need many inks and you don't need a heavy press (a rolling pin works just as well). You just need some space, paper and ideas.

As soon as I started on my first project, I remembered how exciting and addictive printing is and soon my kitchen floor was covered with my experiments. The whole day had flown by and the smell of fresh ink was everywhere. I hope you are inspired by the projects in this book, they really are fun to make and so simple.

Enjoy yourself (and don't forget to stop for lunch).

Christine

THE PRINTMAKER'S KIT

The printmaking room at college was my favourite place to work. I loved the smell, the giant pots of ink, and the anticipation I felt before I saw each print come off the press. My printmaking space at home isn't so grand, but it still smells the same and works just as well.

PRINTING INKS

There are lots of different types of inks on the market, ones that are specific to block printing or screen printing, stencilling or litho. I've used the same ink on all the projects in this book and that is a block printing ink manufactured by Speedball. It is a unique oil-based ink that cleans up easily with soap and water (so no messing around with smelly turps and white spirit). The ink comes in a variety of colours, including a metallic gold and silver (see also pages 12–13), and it's suitable for both fabric and paper.

If you are using it on fabrics, leave it for a week before the first wash. I've put several of my pieces through the washing machine at a low temperature and they came out fine. For a couple of the projects, I've used something different to print with. The Knitty Natty Cushion cover (see page 52) uses emulsion paint and the Bleach Beach Towels (see page 104) use household bleach.

OTHER USEFUL INKY THINGS

The temperature of your workspace can really affect the way your ink works. If the room is too hot, the ink will dry quickly on the plate. The way around this is to add a little ink retarder to your mix, which slows the drying time – particularly useful if you are working in a hot room. If you want to overprint colours to create the effect of extra colours,

then use a transparent extender base, which helps to make inks less opaque. For example, if you were to print a red triangle over a yellow square, where the colours overlap you will get an orangey hue.

ROLLERS

The rollers used to roll out the ink come in a variety of sizes. They range in price and quality and can get super expensive. I've acquired a variety over the years, such as a beautiful wood and brass-handled one with a durathene roller, which is quite small so good for little blocks. The one I use the most has a 10cm wide soft rubber roller and a plastic handle that I got from a general art shop. It cleans up well and rolls the ink on smoothly and evenly. It's useful to have more than one roller as it saves time if you need to have more than one colour on the go. You can also use a clean roller to apply pressure to the back of a block when you are printing.

PALETTE KNIVES

These long flat bendy knives are great for mixing inks together, spreading ink out and also scraping excess ink off the glass plate at the end of a job. There is something hypnotic about mixing colours together with a palette knife. If you don't have a palette knife, any wide bendy round-tipped knife will work.

GLASS PLATE

You need a flat surface to mix and roll the inks out onto. A glass plate is perfect. Ideally, a toughened glass one. Alternatively, use a large smooth bathroom tile or a mirror tile. You can buy special ink-mixing trays that have a lip around the edge to stop the ink escaping, which is probably a wise precaution.

BAREN

A baren is a disc-shaped tool with a handle used to apply pressure to the back of your block so you get a nice even print.

ROLLING PIN

If you don't have a baren or you are printing a large print, then using a rolling pin over the back of the block is a good way to apply an even pressure. You can also use rolling pins for making repeat print patterns, such as on the Lacey Casey (see page 46).

SINK

A supply of running water and a sink is essential for printmaking as there are times when it gets quite messy (or when you need to fill the kettle for a cup of tea). Most inks these days clean up with soap and warm water.

RAGS

When I was experimenting with the bleach patterns on the towels on page 104, I practised on lots of cheap flannels, which I now use constantly to clean up my inks, rollers and glass plates. I also have a cheap pack of moist tissues (the sort to clean babies' bottoms) that are really useful to wipe away excess ink on the printing block or quickly clean up your fingers.

PERSPEX BLOCKS

Different sizes of Perspex blocks make a good base for your Lazy Lino cuts. As they are transparent, it's easy to line up the block when doing repeat prints or multi-coloured ones. You can buy them in a variety of ready-cut sizes. If you are making oversize blocks, such as on the Knitty Natty Cushion (see page 52) or Ric Rac Scarf (see page 48), then squares of MDF or thick cardboard work well.

MASKING TAPE

Use masking tape to fasten your sheet of Lazy Lino to the cutting mat when using a craft knife. This will stop the foam slipping around and make it easier to cut. Masking tape is also invaluable for keeping the objects you are printing on flat and in one place.

SAFEPRINT FOAM SHEETS (AKA LAZY LINO)

These sheets of polystyrene are 3–5mm thick and come in different sizes, ranging from A4 upwards. You can buy sheets with a self-adhesive back, which is useful for adhering to a Perspex block, or you can just use double-sided tape, as I like to do. The foam is easy to mark with a pencil or by pressing other objects into it. It is a much cheaper alternative to lino or wood. I have used Lazy Lino for all the block printing projects in this book. You can use softcut or lino (see below) to make the blocks, but you will need special lino cutting tools.

SOFTCUT AND LINO

These two products require lino cutting tools to engrave them so they are a little more fiddly (and a little bit more dangerous towards your fingers!) and the blocks take longer to prepare. Saying that, the final block will last forever.

CRAFT KNIFE AND SCISSORS

Lazy Lino is easily cut with scissors or a craft knife. I prefer a knife as you can get a more intricate cut, but scissors are great, too, and safer for children.

METAL RULER

It's easier to cut a straight line with a metal ruler. Fact.

CUTTING MAT

Use a cutting mat so that you don't engrave your work surface with lines and patterns from the craft knife.

DOUBLE-SIDED TAPE

Use this to fix Lazy Lino to a Perspex block.

PENCILS AND PENS

As Lazy Lino marks so easily, it's best to experiment with a range of pencils and pens to see which one makes the type of line and pattern you like the most. I use a sharp (but not too sharp) pencil and a propelling pencil if I want a super fine line (see also page 14).

LIGHTER FLUID

Use a little of this on a tissue or rag to clean leftover bits of double-sided tape from a Perspex block before re-using it. It leaves a little residue, so polish the Perspex with a clean cloth afterwards. Always keep lighter fluid in a safe place and clearly marked as it can be harmful if inhaled or swallowed.

NEWSPRINT

I bought a big pack of newsprint (chipshop paper) before I started this book. It's great to test prints out on and also to protect floors and table tops.

PAPER

It's fun to experiment with printing on all kinds of paper as each one gives a different effect. I love brown paper, and tracing paper can give some layered effects. If you want to make simple art prints with your blocks, then a nice heavyweight smooth cartridge paper works well.

FABRIC CARE

The Speedball printing inks I've used on the projects are perfect for cotton, polyester, blends, linen, rayon and other synthetic fibres but aren't great on nylon. I have also used them on velvet cushion covers and fabric-covered boxes, stretchy T-shirts and baseball boots. Leave your printed fabric for a week before washing and use a low temperature and mild soap when putting it through the washing machine.

CARBON PAPER

Useful if you aren't confident about transferring the patterns onto the Lazy Lino (see page 14 for how to use the carbon paper).

FABRIC-COVERED BOARD

Sometimes when printing on fabric you can get a better print if you print onto a slightly padded surface. This isn't always the case, though, so it's good to experiment with an offcut of fabric first.

It's easy to make a padded board – take a piece of MDF measuring about 50 x 70cm (to stretch a T-shirt over), some pieces of wadding and cotton that are large enough to stretch over the board, and a staple gun. Stretch the wadding over the MDF and staple gun it in place on the reverse. Repeat with the cotton fabric and you're done.

PVA GLUE

This thick white waterproof glue is used in several projects to hold the surface used for printing to the block and also to protect it from soaking up too much ink (see the Delicate Doily Bunting and Lacey Casey on pages 42 and 46). When covering the surface in glue, use an old stubby paintbrush to get the glue into all the nooks and crannies and leave to dry overnight. It can also be used to make an actual surface for printing (see the Sunflower Tablecloth on page 110). Used as a drawing tool by squeezing the glue from the nozzle, like icing a cake, it dries in a raised line that can then be printed from.

STRING

This is another useful thing for making printing blocks with. Covered in PVA and wound about into patterns on a piece of card or wood gives an attractive effect when printed (see the Ginkgo Leaf Blind on page 100).

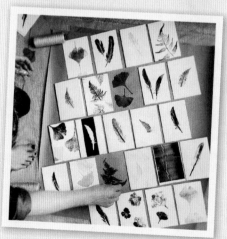

11

COLOUR MIXING

We are taught in school that red, yellow and blue are the primary colours. These are colours that cannot be created by mixing other colours together, but when they themselves are mixed together you can create a range of other colours.

As these three colours are so super useful you can get away with buying these plus white and black when looking to purchase inks for your printing projects. However, if you add in a tube of magenta and a tube of turquoise, suddenly you have a lot more subtle changes in colour at your disposal. Printing inks also come in a variety of ready-mixed colours, each one a strong vibrant shade. The inks I've used on the projects in this book come in a range of 13 different colours, including gold and silver, but it's my tubes of white, turquoise, magenta, yellow, blue and red that are almost empty.

The illustrations on these pages show what happens when you mix certain colours together… but be prepared to experiment, the tiniest change in quantity of colour can really affect the shades you create.

MIXING COLOUR TOP TIPS

1 When trying to mix a new hue, start by squeezing a little of each colour you are going to use onto a sheet of scrap paper. Mix them together with a finger until you have the right shade, remembering the rough amount of each colour used (for example, you may have used twice as much red as yellow to make a particular shade of orange). Once you are happy with a colour, then you can mix it on a large scale.

2 Use white to make a colour lighter, but using black to make a colour darker often kills the colour and makes it dull. So use the tiniest bit as it is so powerful or use other colours to make the shade darker (browns, blues, greens and reds all help).

3 If you want a pale colour, add a little of the colour to white rather than the other way round.

4 Darker colours have the most pigment in them, so you often need less of them. Mix them in a little at a time.

1 PART YELLOW + 1 PART RED = ORANGE

1 PART YELLOW + 1 PART TURQUOISE + 1 PART RED = OLIVE

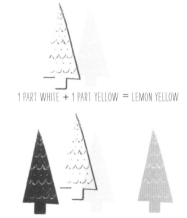
1 PART WHITE + 1 PART YELLOW = LEMON YELLOW

1 PART YELLOW + 1 PART BLUE = GREEN

1 PART YELLOW + 1 PART TURQUOISE + 1 PART RED + ½ PART WHITE = PALE OLIVE

1 PART BROWN + 1 PART WHITE + 1 PART YELLOW = OCHRE

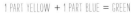
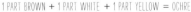

5 There are some colours that are trickier than others to mix. I spent ages trying to make up olives, ochres and greys (without using black). In the end, I found a tube of ready-mixed brown ink really helped.

6 To inject a little bit of sparkle, add metallic silver or gold to your colours.

MIXING UP THE INK

When you have worked out the correct colour combination to create your desired shade, start mixing the inks together on your plate of glass using a palette knife. Work at the top of the glass plate so you have space to roll the ink out later. Swipe the knife back and forth blending the inks, then scrape up all the ink and dollop it back down on the glass and swipe again. It's a lovely thing to watch the colours blending. When the colours are well blended, use the roller to roll out a layer of ink in the lower half of the glass plate (for information on ink consistency, see page 15). To ensure the colours are fully mixed together, roll the ink out left to right, then up and down. Don't try to roll out all the ink at once as it will dry out quickly. Instead, leave a reserve of ink at the top of the glass plate.

1 PART WHITE + 1 PART TURQUOISE = PALE TURQUOISE

1 PART WHITE + 1 PART BLUE = WEDGWOOD BLUE

1 PART MAGENTA + 1 PART BLUE + 1 PART WHITE = LILAC

1 PART BROWN + 1 PART WHITE + 1 PART BLUE = STEEL GREY

1 PART TURQUOISE + 1 PART BLUE = TEAL

2 PARTS GREEN + 1 PART BLACK = DARK GREEN

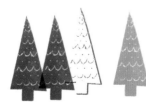
2 PARTS BLACK · 1 PART WHITE = DARK GREY

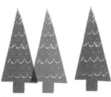
1 PART RED + 1 PART BLUE = PURPLE

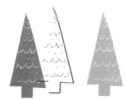
1 PART MAGENTA + 1 PART WHITE = PALE PINK

TOP TIP

Sometimes you might not want to completely mix your inks together. You can get an attractive ombre effect if you only blend your inks in one direction.

13

PRINTING TOP TIPS

★ ★ ★ ★ ★ ★ ★ ★ ★ ★ ★ ★ ★ ★ ★

USING PERSPEX BLOCKS

The advantage of using a Perspex block rather than one made from wood is that if you are making a multi-coloured print, being able to see through the Perspex when lining up the block makes it much easier to get a perfect print.

Many craft shops sell Perspex blocks with grooves down the side for your fingers, but it's often cheaper to get a larger piece of Perspex cut down into smaller pieces. I bought several of mine on eBay and they were great value.

To clean leftover double-sided tape from your Perspex blocks before using them again, use lighter fluid. First remove as much of the Lazy Lino from the block using your fingers, then wash the remaining ink away with warm soapy water. Any sticky bits left on the blocks will come off with a squirt of lighter fluid and a rub with a rag.

TRANSFERRING PATTERNS

Use carbon paper to transfer a pattern from its source to the Lazy Lino. Place a piece of the carbon paper between the template and the Lazy Lino, carbon-side down, and draw over the template with a pencil (and a light touch) to transfer the pattern onto the foam.

There are also lots of doodlesque patterns in this book, which are made up of simple lines, dots, dashes, hearts and scallops. I've drawn the patterns clearly on the templates so they should be easy to copy.

MAKING INDENTATIONS

I tried a whole host of pens, pencils, pins and pointy things when looking for the best tool to make indentations in the Lazy Lino. I found one pencil that worked a treat, not too sharp and not too blunt; it didn't tear up the foam, but left a nice crisp line. Perfect! For super fine lines I found the tip of a propelling pencil was great, but be careful, because if your lines are too fine, they will fill in with ink.

When making marks, don't press too hard as the foam is so soft, a little pressure is enough to get a good indentation. The harder you press, the wider your pattern will be when you come to print. So again experiment until you find a pressure and a result you're happy with.

MAKING PRINTS

Always do a test print of your block before printing onto your chosen surface. This not only allows you to work out the pressure you need to apply to get an even print, but also shows if there is anywhere that could do with a deeper indentation to get a clear pattern. Also you often get a better print the second or third time as, by then, there is a good base layer of ink over the block.

MAKING ENDURING BLOCKS

I could only find one slight downside to using Lazy Lino instead of a more substantial carving block. Because the foam is quite thin, over time your print could get a bit woolly and the edges and pattern loose their crispness. When doing more frequent pattern repeats (like on the Nordic Forest Lampshade on page 64), you may need to cut out new trees during the project. For a longer-lasting block, all the Lazy Lino blocks in this book can easily be cut from softcut, wood or lino.

INK CONSISTENCY

Each printing material requires a different consistency of ink to get the best print. Lazy Lino prints require a fine consistency, while potato and found object printing need a medium consistency, and blocks made from fabric (such as the Delicate Doily Bunting on page 42) use a thicker consistency.

I usually squeeze out about 3cm of ink when starting a project. I find this is enough to get a good layer of ink rolled out and several prints done and not too much is wasted at the end. Obviously this all depends on the size of the block you are printing with and how many times you print with it. (Is it a repeat pattern? Are you printing all your Christmas cards at once?) As you get used to using the ink, you will come to tell how much ink you roughly need for a project.

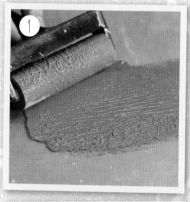

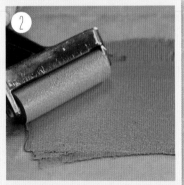

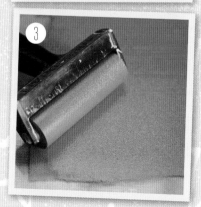

THICK CONSISTENCY

Squeeze out the ink at the top of the glass plate to allow space to roll the ink into the necessary consistency. For a thick consistency, you usually have to only roll the ink a couple of times. The ink forms large peaks on the glass plate and roller as you roll and it sounds quite 'squelchy'.

MEDIUM CONSISTENCY

If you are printing on fabric or with a large block, then a medium consistency is good. Roll the ink out over a larger area of the glass plate to get this consistency. The peaks are smaller and it begins to feel quite 'tacky'.

THIN CONSISTENCY

Printing with smaller foam blocks and on paper usually requires a thin consistency of ink (if the ink is too thick, then your block may slip on the paper and the etched lines may fill in). Roll the ink down the glass plate until you have a fine layer of ink. If you roll the ink out too fine, use a palette knife to collect all the ink and start again.

MAKING AND USING A LAZY LINO TEMPLATE

Remember that printing works with reversed images. So to make sure your image looks the right way when printed, it needs to be stuck to your block back to front. This means that any words you use need to be drawn in reverse... tricky.

Pencil

Safeprint foam sheet

Masking tape

Cutting mat

Craft knife

Metal ruler

Double-sided tape

Perspex block

Printing ink

Palette knife

Glass plate

Roller

Baren or rolling pin

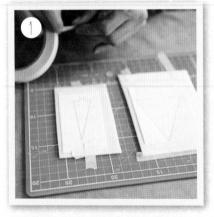

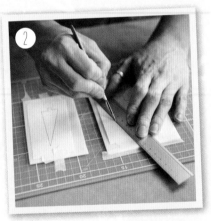

1 Copy your chosen template onto white paper (in these pictures I've used a Nordic Forest tree from page 123). Using masking tape, stick the template to a similar size piece of foam. Then tape them both to your cutting mat to stop the Lazy Lino moving around, which makes it easier to cut fiddly bits.

2 Using the craft knife (and ruler if necessary), cut away the excess Lazy Lino. If your shape has curved sides, it's easier to cut it away in sections than doing it all at once.

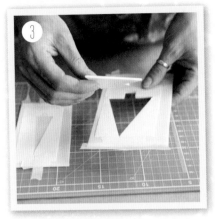

3 Remove the tree from the excess Lazy Lino.

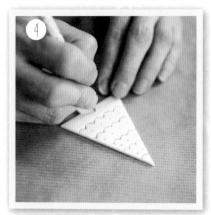

4 Use a pencil to mark the tree with decorations. You don't have to press hard to get an indentation.

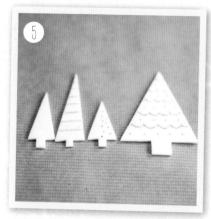

5 Repeat steps 1–4 with the rest of the pieces that you need for your project.

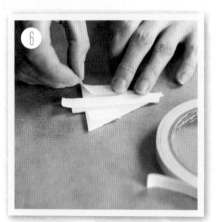

6 Place strips of double-sided tape over the back of the tree. It doesn't have to be completely covered, but make sure all the important areas, including narrow parts, are taped. (If you are using a foam sheet with a sticky back, you can bypass this step.)

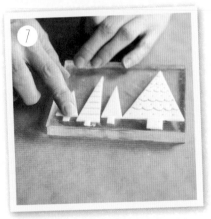

7 Remove the backing from the tape (or Lazy Lino) and place the tree onto a suitably sized Perspex block. If you are printing several colours in one project (such as for the Bloomin' Marvellous Storage Boxes on page 86) make up a block for each of the colours.

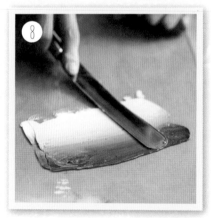

8 Squeeze out your chosen inks onto the glass plate and use a palette knife to start blending the inks together (see pages 12–13 for colour mixing tips).

CONT. >>>

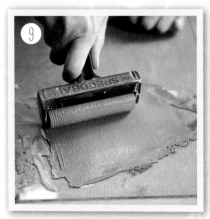

9 Roll out the ink with a roller to get an even coverage, rolling first one way, then the other. Make an appropriate consistency of ink as described in each project and on page 15.

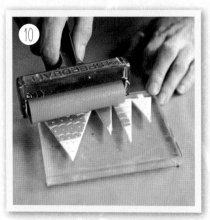

10 When you have rolled the ink to the right consistency, start rolling up your block. Make sure all the Lazy Lino is covered.

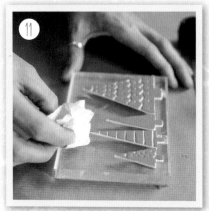

11 If you have got any ink on the Perspex block, wipe it away with a tissue or damp cloth and make sure your fingers are clean too – you don't want to ruin your masterpiece with grubby fingerprints.

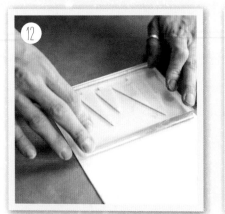

12 Carefully place the block face down onto the surface you are printing on. Press gently onto the back of the block with your fingers to fix it in place.

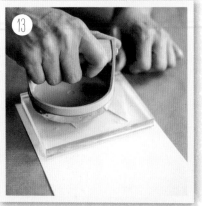

13 Use the baren or rolling pin (or your fingers) to apply an even pressure across the whole back of the block.

14 Lift the block from the printed surface. Ta-dah!

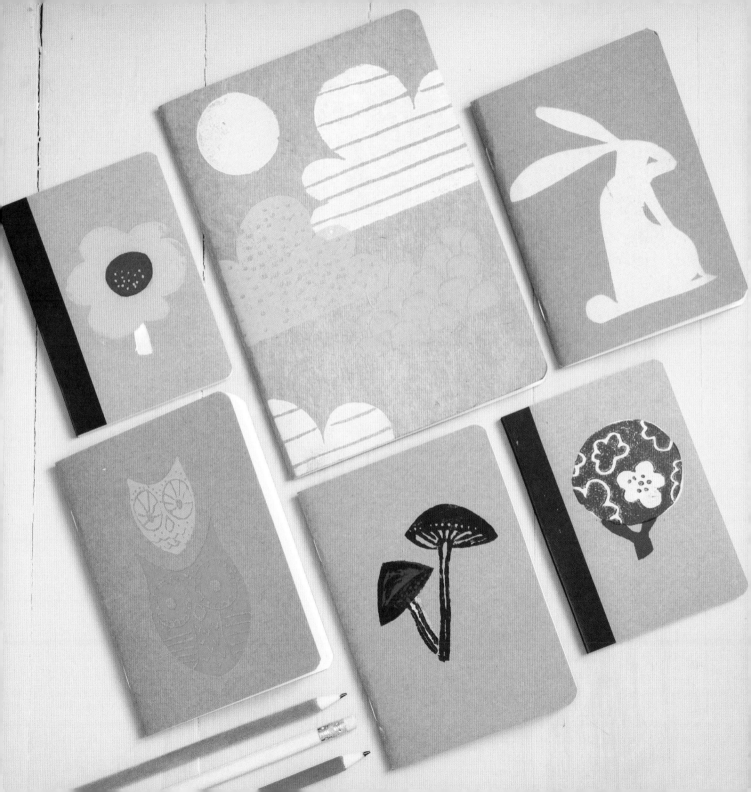

PRINTING WITH FOUND OBJECTS

Wherever you are sitting reading this book there is probably something within your eyesight that would make a good printing block. Be it a potato, a potato masher, a button, a bowl or a bracelet, anything that has a texture on it or an interesting shape will do. When covered with ink and rolled, pressed or stamped onto a surface, it will leave some kind of imprint behind. It may be an amazingly detailed print from feathers and leaves or a bold repeat pattern from kitchen cutlery. Whatever it is, it will be fun experimenting.

• Botanical Greetings Cards • Atomic Kitchen Tea Towels
• Glittery Giftwrap • Button Boots • Feather Cushion
• Hiawatha T-shirt • Delicate Doily Bunting
• Lacey Casey • Ric Rac Scarf • Knitty Natty Cushion
• Shimmering Scales Napkins

BOTANICAL GREETINGS CARDS

Certain leaves and feathers make amazing prints. They are so detailed that they look like an incredible Victorian etching, but the printing process is probably one of the simplest there is.

SUPPLIES

Black printing ink

2 glass plates

Roller

A selection of feathers and leaves

Plain greetings cards

Kitchen paper

Rolling pin or second roller

There is such a variety of textures in the natural world, all perfect for some experimental printing. I've found the best leaves to print are ones that aren't too fleshy and have a good grain or vein structure. Often the underside of a leaf has more prominent veins, so use this side to take the print from. Ferns, feathers and ginkgo leaves work well, but as soon as you start this project I bet you will be wanting to print with your whole garden.

1 Squeeze some black ink onto one of the glass plates and roll it out to a fine consistency (see page 15). Make sure the roller is coated with a thin layer of ink. Place the feather or leaf onto the second glass plate and gently roll over it with the roller.

2 Make sure the feather is all covered with ink and then carefully lift it off the glass plate.

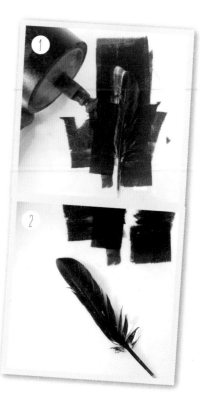

CONT. >>>

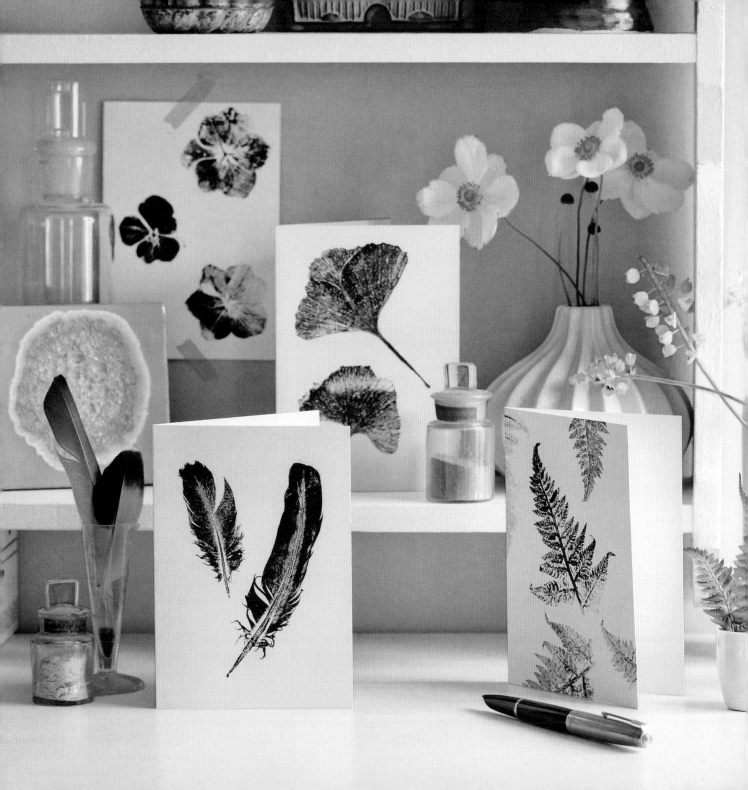

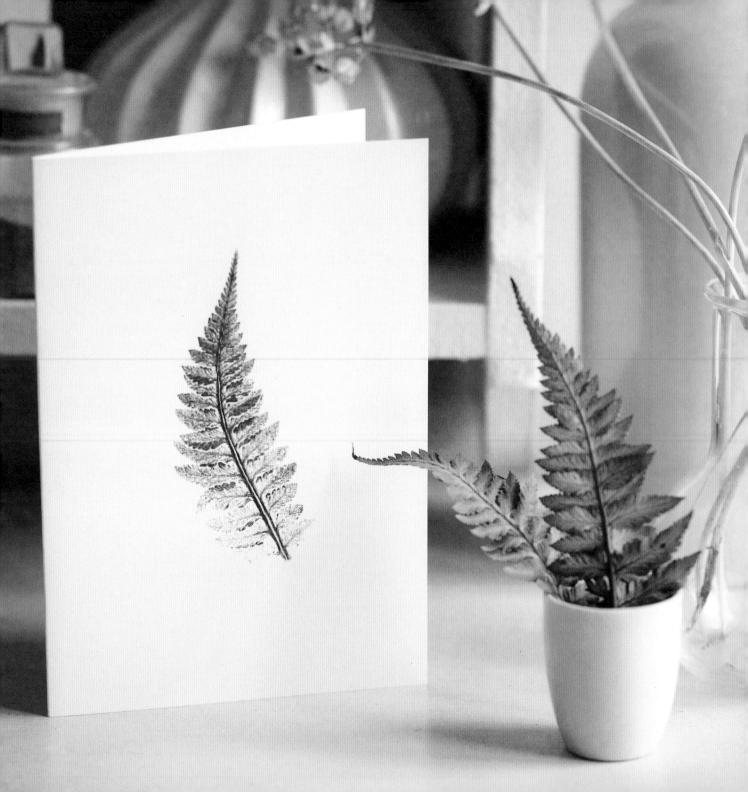

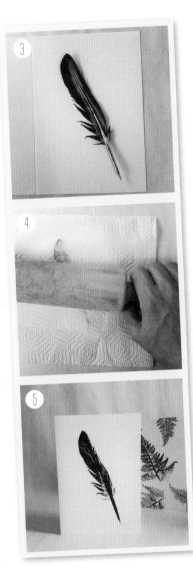

>>>

3 Place the unfolded greetings card on a flat surface and position the inked-up feather on the card, ink-side down.

4 Lay a piece of kitchen paper over the feather and card and gently (so as not to move the feather) but firmly (to apply some pressure), roll over the feather and kitchen paper using a rolling pin or clean roller.

5 Carefully remove the kitchen roll and feather to reveal the print.

EXTRA!

Instead of printing greetings cards, why not try a larger feather or a variety of leaves to print a picture for your wall.

I rolled some gold ink onto the tip of the feather below before I printed it to make this beautiful two-toned effect.

Make a negative print by placing the feather or leaf onto the card and rolling over it once with an inked roller. This will leave a silhouette on the card. If you then roll the roller across another piece of paper, you will get a print of the feather from the roller.

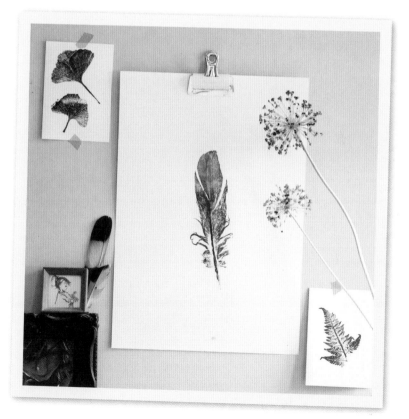

ATOMIC KITCHEN TEA TOWELS

★ ★

The prints on these tea towels are all made using a variety of kitchen utensils found in most homes. The colourway gives them a cool retro feel.

SUPPLIES

Plain white tea towels, washed and ironed

Masking tape

Black, pale turquoise and ochre printing inks (see pages 12–13 for colour mixing tips)

Palette knife

Glass plate

Roller

Sandpaper (optional)

Variety of kitchen utensils (see diagrams on page 28 for specifics)

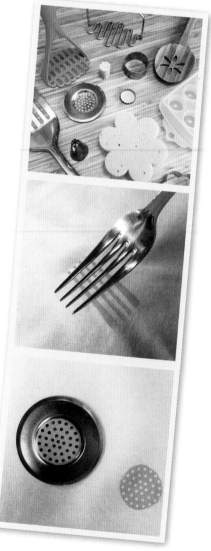

1 It's amazing what you can find around the house that makes a good print! On these tea towels I've used a potato masher, a sink drainer, some scone cutters, a bottle top, a couple of icing nozzles, a spatula, a fork and the end of a clothes peg. You can follow the patterns I've made here or create your own.

2 Lay a tea towel out on a flat surface and tape it down at the corners to it is god and flat.

3 Choose which tea towel design you wish to print first (see your choices overleaf) and follow the instructions on the appropriate illustration.

4 Mix up each ink on the glass plate and roll out to a medium consistency (see page 15). If the ink doesn't stick to a utensil very well, rub a little sandpaper over it (before you ink it up!) and also allow the ink to dry slightly before printing.

CONT. >>>

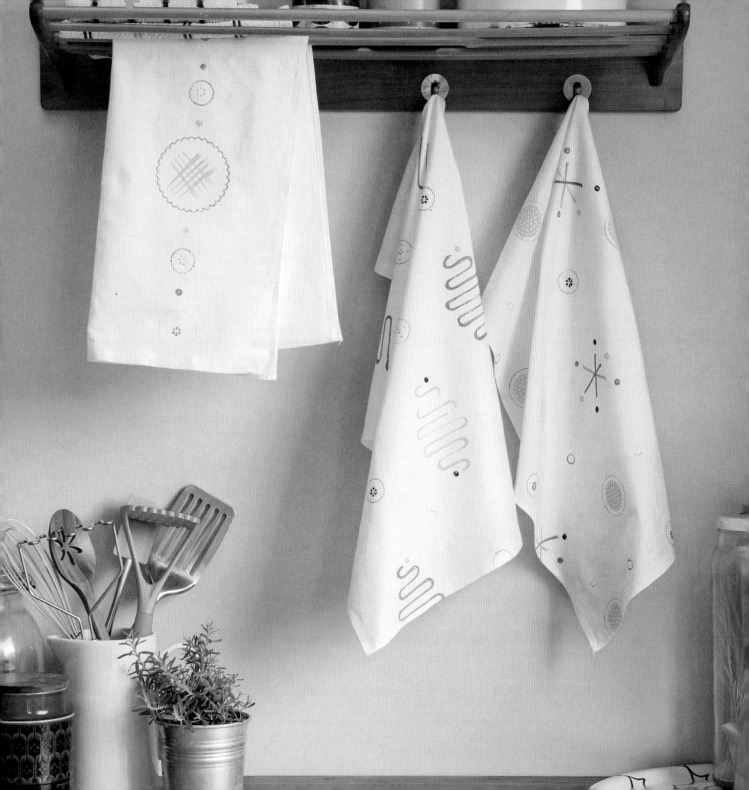

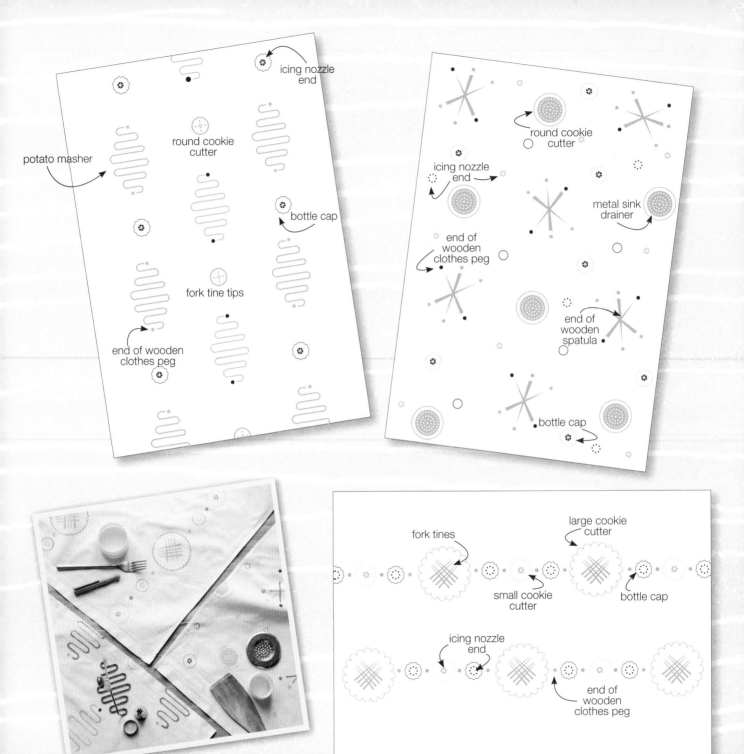

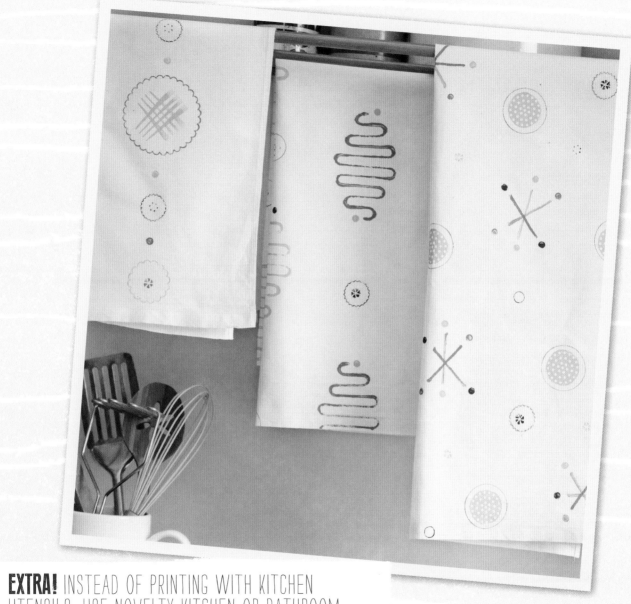

EXTRA! INSTEAD OF PRINTING WITH KITCHEN
UTENSILS, USE NOVELTY KITCHEN OR BATHROOM
SPONGES TO PRINT BOLD AND COLOURFUL PATTERNS.

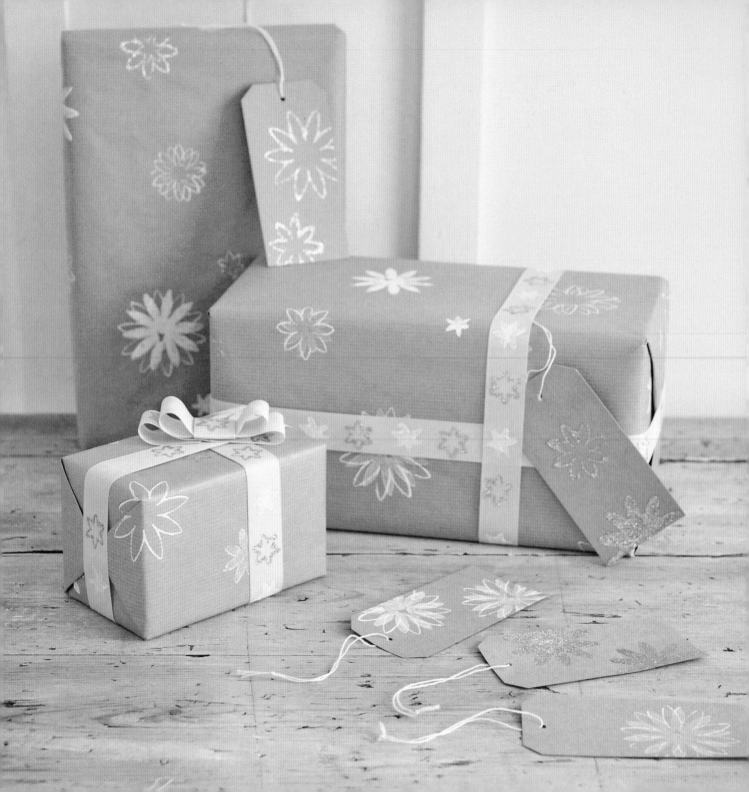

GLITTERY GIFTWRAP

White ink and glitter give the humble brown paper used for this project a stylish look. Follow these steps and you too can make expensive looking wrapping paper quickly and cheaply.

CONT. >>>

SUPPLIES

Potato or sweet potato

Vegetable knife

Cookie or icing cutters in 3 sizes

Kitchen paper

Brown paper

Masking tape (optional)

White printing ink

Glass plate

Roller

PVA glue

Glitter

Good length of 1cm wide ribbon

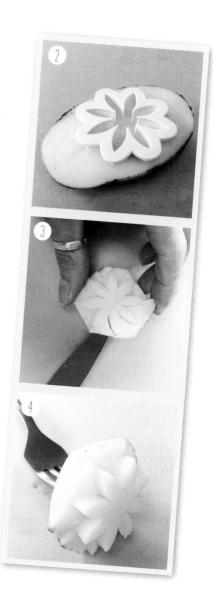

1 Cut the potato in half so you have an area of flat potato large enough for the cookie cutter to sit on it easily. Cut a slice off the base of the potato to make it sit flat on your work surface.

2 Press the cookie cutter into the potato to mark the shape.

3 Use the vegetable knife to cut away the excess potato so the shape left by the cutter sits proud by about 1cm. Repeat with other cutters for different sizes.

4 If you are using a normal potato, dry the cut surface off by dabbing it with a piece of kitchen paper and leaving to dry out while you prepare the ink and paper. Stick a fork into the back of the potato, which helps with moving the potatoes around when printing.

〉〉〉

5 Roll out 1m of brown paper onto a flat surface covered in newspaper (to collect the glitter). If it tends to roll back up, fasten it down at the edges with masking tape.

6 Squeeze some white ink onto the glass plate and roll it out to a medium consistency (see page 15). Then use the roller to roll the ink onto the potatoes and start printing.

7 To make the outline flower shapes, print using the cookie cutters with ink rolled onto their surface.

8 Print the largest flower shapes first, using both the potato and the cutter, printing in a random pattern over the paper. Then fill in the rest of the paper with the medium and smaller shapes.

9 Overlap the cutters and potatoes to get more intricate flower shapes.

10 To make the glitter shapes, print with PVA glue instead of ink and then sprinkle a generous amount of glitter over the area. When finished, lift the wrapping paper up and collect the glitter on the newspaper below.

11 Print the gift tags in a similar way. If you are making glitter tags then it can be easier to gently press the glued tag into a pile of glitter.

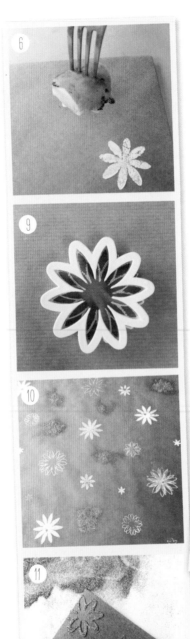

TO MAKE THE RIBBONS

12 Lay the ribbon out flat and tape it down at the ends. Print along the length of the ribbon, alternating between ink and glue. Sprinkle glitter as before onto the glue and shake off.

ALSO LOOKS GOOD ON

Greetings cards: make a complete range of goodies by printing up several greetings cards while you are making the wrapping paper.

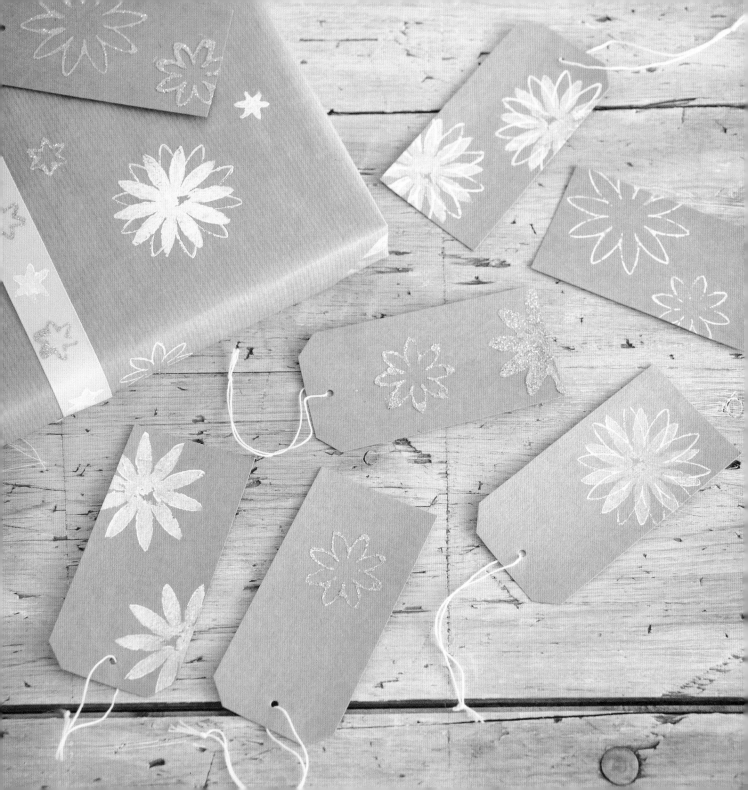

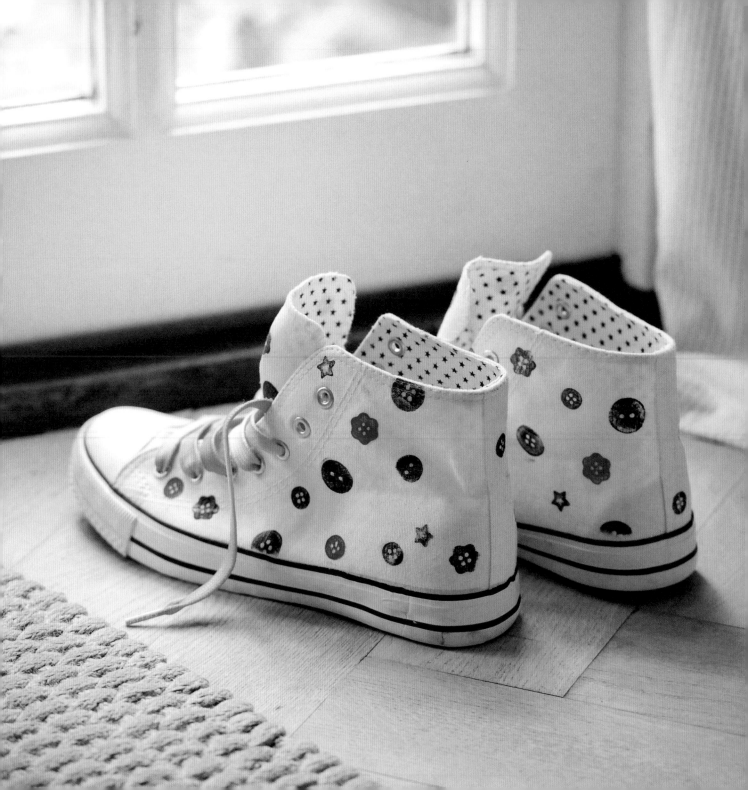

BUTTON BOOTS

Printing with buttons gives a quirky alternative to a polka dot print. One colour makes them more sophisticated, but more colours = more fun!

1 Make two rough semicircles from the cardboard to place inside the toes of your shoes. This gives a firmer base to print onto. Also stick some tape around the rubber edge and remove any shoe laces.

2 Choose a variety of buttons in different shapes and sizes. The buttons that work best are ones that have a very flat side and no indentations or ridges. If they are shiny, give them a light rub with sandpaper on the flat side to help the ink adhere better.

3 Mix up a grey ink on the glass plate and roll it out to a fine consistency (see page 15).

4 The best way to get firm and even pressure on the button is to stick it directly to your index finger using double-sided tape.

5 Roll the ink onto the button and begin printing. To get a good print, use your index finger and thumb in a pinching action with the boot fabric in-between, pressing the fabric onto the button. Swap buttons occasionally so you get an attractive random pattern.

6 Roll out some orange ink and print a few buttons to add colour. Leave to dry overnight.

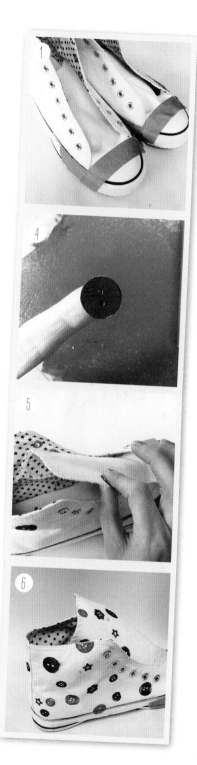

FEATHER CUSHION

★ ★ ★ ★ ★ ★ ★ ★ ★ ★ ★ ★ ★ ★ ★ ★ ★ ★ ★ ★

Sweet potatoes are the perfect shape to make feather prints from. They have a lower water content than potatoes so you can get a crisper print (no pun intended). The velvet nap on this cushion gives the print a silvery glow.

SUPPLIES

Sweet potatoes

Vegetable knife

Coloured pencil

Lino cutting tool

Forks

White, pink, orange, turquoise, green, purple and gold printing inks (see pages 12–13 for colour mixing tips)

Palette knife

Glass plate

Roller

Velvet cushion cover

Masking tape

1 Slice the sweet potatoes in half lengthways.

2 Use a coloured pencil to draw a rough guide of the feather on the potato.

3 Use the vegetable knife to cut and trim the stalk of the feather.

4 Take the lino cutting tool and carefully cut channels in the potato to represent the central stem and the feathers. Cut one long channel down the centre and then several fanning off from this on either side. Follow the illustrations below for ideas.

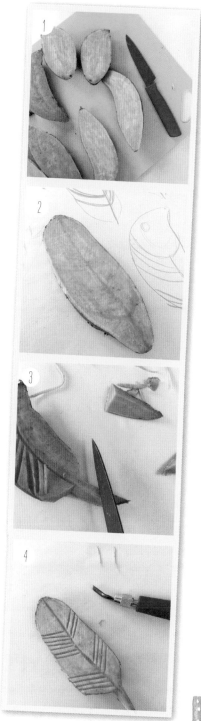

CONT. ⟩⟩⟩

>>>

5 Repeat steps 2 and 3 on five other halves. You can use the knife to shape the whole potato if you are not happy with the natural shape.

6 Stick a fork in the backs of the potatoes to make them easier to handle and you can also apply more pressure when printing. On the glass plate, roll out the white ink to a medium consistency (see page 15), then ink up the potato halves.

7 Lay the cushion cover out on a flat surface. Tape the edges down so it can't move around. Start in one corner of the cushion and begin printing by placing the potatoes in a random pattern. Try to make the feathers curve into one another. You can probably get at least two printings from each inking of a potato. The second inking will be paler than the first, but this gives an airy feel to the design.

8 Continue until the whole cushion cover is filled.

9 To print the coloured tips, clean up the potatoes and cut the tip of them off in a 'V' shape. Stick a fork in the backs of these too.

10 Roll out the coloured inks to a medium consistency and print by matching up the feather tips with their corresponding feather.

11 Leave the cover to dry before stuffing with a cushion pad.

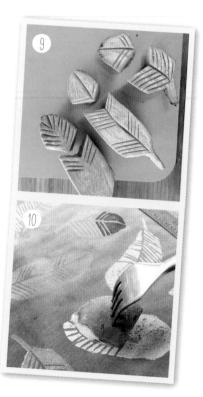

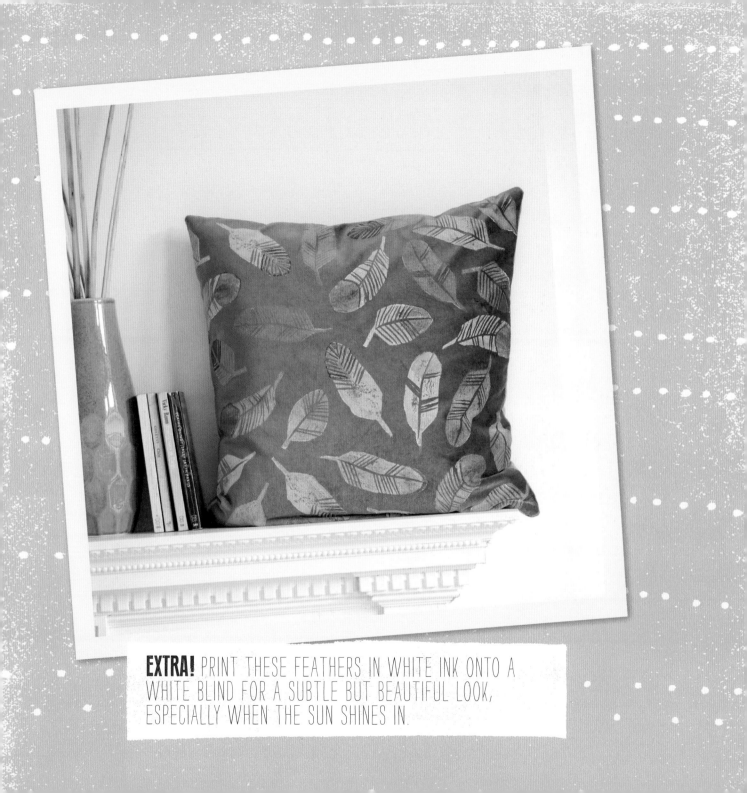

EXTRA! PRINT THESE FEATHERS IN WHITE INK ONTO A WHITE BLIND FOR A SUBTLE BUT BEAUTIFUL LOOK, ESPECIALLY WHEN THE SUN SHINES IN.

HIAWATHA T-SHIRT

This T-shirt uses the same sweet potato printing technique as the Feather Cushion on pages 36–9.

Feather Cushion on pages 36–9.

SUPPLIES

T-shirt, washed and ironed

Masking tape

Sweet potatoes

Vegetable knife

Coloured pencil

Lino cutting tool

Forks

White, magenta, orange, green and dark green printing inks (see pages 12–13 for colour mixing tips)

Palette knife

Glass plate

Roller

1 Place the T-shirt on a flat surface and tape it down.

2 Follow steps 1–4 of the Feather Cushion (see pages 36–7) for making the potato feathers. You need to make four feathers ranging in size from approximately 6cm to 12cm.

3 Mix up some orange ink on the glass plate and roll out to a medium consistency (see page 15). Start with the largest feather and print it on the centre of the neckline of the T-shirt. Roll the ink onto the potato so you get an even covering. Work out from this feather printing the rest of the feathers in different coloured inks. On the back of the T-shirt I included a leaf in a paler green than the one on the front.

4 Use smaller feathers each time and work symmetrically around the neck line. Allow the T-shirt to dry.

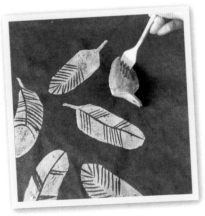

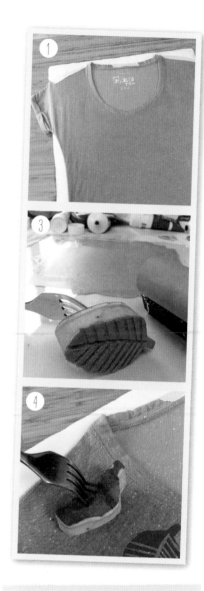

ALSO LOOKS GOOD ON …

Tote bags: try a repeat pattern of the same feather in one colour or a random pattern like the cushion cover on the previous page.

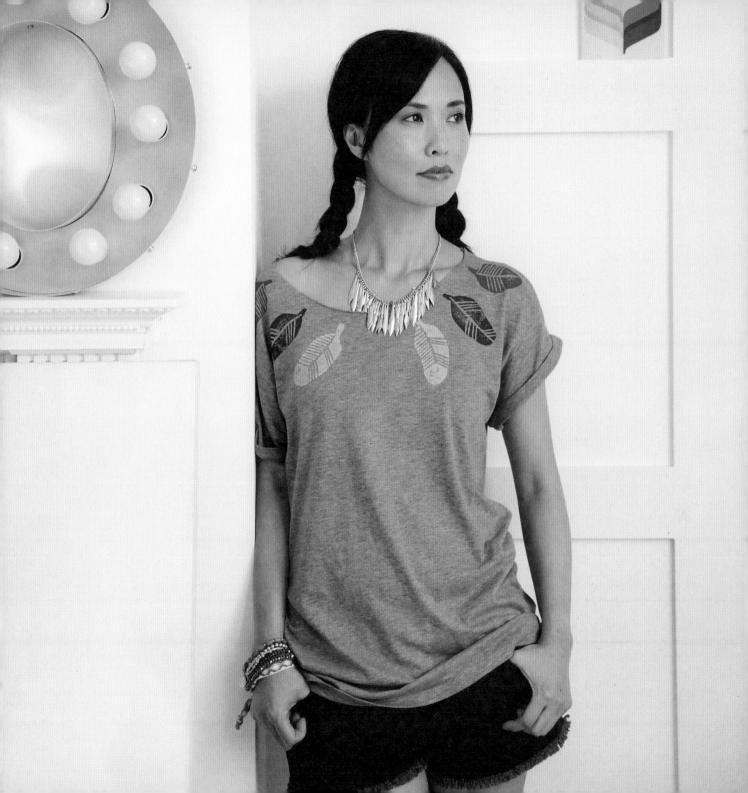

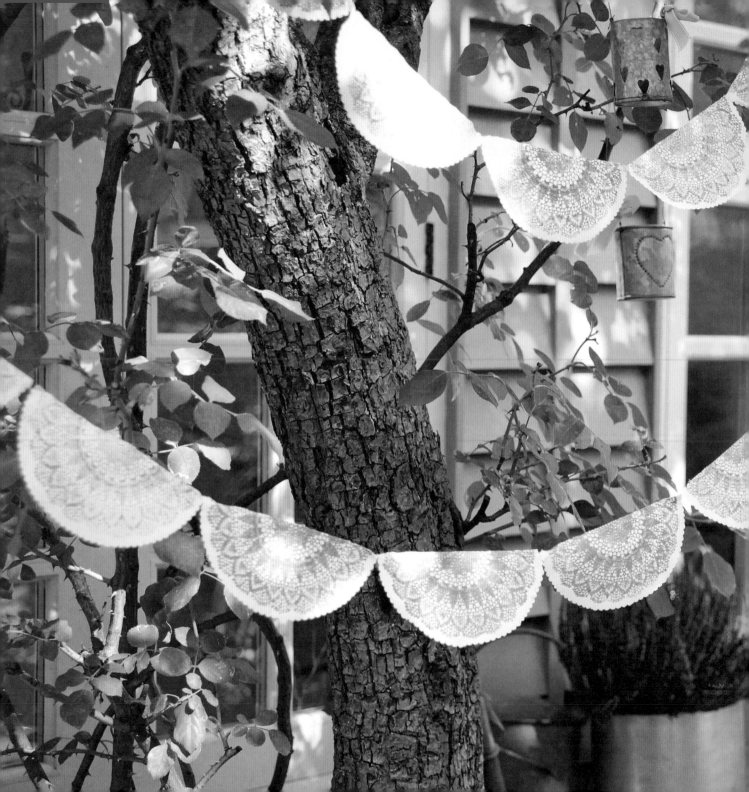

DELICATE DOILY BUNTING

An intricate lace doily makes a beautiful printing block, giving an amazingly delicate print which makes a nice alternative to traditional bunting.

SUPPLIES

1sq m white cotton

Piece of MDF wood or thick card 2cm larger all around than the doily

PVA glue

Paintbrush

Lace doily

Pink and white printing inks (see pages 12–13 for colour mixing tips)

Palette knife

Glass plate

Roller

Rolling pin

Pinking shears

Scissors

1m thin white ribbon

Sewing machine

PREPARE THE FABRIC

1 Cut the white cotton into squares the same size as the wood or card block.

PREPARE THE DOILY BLOCK

2 Cover the piece of card or wood with PVA glue and use the paintbrush to spread it across the whole block.

3 Place the doily on the glued surface and use the brush in a downward dabbing motion to firmly stick the doily to the block. Add more glue to the top of the doily and get it into all the nooks and crannies. Leave the doily to dry completely – ideally overnight.

4 Mix up some pink ink on the glass plate and roll it out to a medium consistency (see page 15). Don't worry about mixing enough ink to print all your fabric in one go – the variety of shades of pink mixed in each batch gives a pretty ombre effect.

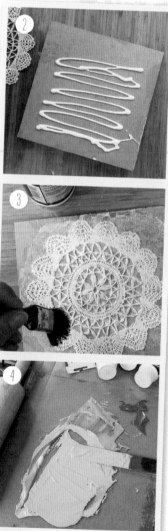

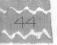

5 Roll up the doily with the ink and wipe away any that gets onto the block.

6 Place a piece of cotton onto the doily block and use a rolling pin to apply even pressure to the fabric. Carefully peel the fabric from the block and leave it to dry.

7 Ink up the doily block after each print. The first two or three prints may be a bit pale as the ink takes time to infiltrate the doily, but after the first few you will get an amazingly detailed print.

8 When all the prints are dry carefully cut around each doily with the pinking shears leaving about a 1cm border all around. Then cut each one in half using normal scissors.

TO MAKE THE BUNTING

9 Pile all the doily halves together and use a sewing machine set to a simple straight stitch to join them together. Run each doily half through the machine about 5mm from the straight edge of the doily and butting the next one up to it as you go. Alternatively, you can hand sew the doily halves together with a couple of stitches at each side.

10 Cut the white ribbon in half. Fold one piece in the middle and stitch this fold to one end of the bunting. Repeat on the other end.

11 Hang your colourful bunting somewhere lovely.

ALSO LOOKS GOOD ON ...

Table linen: using the same doily (or a mixture of two or three) to print on coasters, napkins and place mats allows you to make a whole set of table linen cheaply. Try printing on felt or other non-fraying fabric so that you don't have to hem the finished articles.

LACEY CASEY

Using a rolling pin as a printing tool is an easy way to not only get a repeat pattern but also a cool graduated ombre effect.

SUPPLIES

Pieces of lace and ribbon the circumference of the rolling pin and a similar thickness so they print evenly

PVA glue

Wooden rolling pin

White and Wedgwood blue printing inks (see pages 12–13 for colour mixing tips)

Palette knife

Glass plate

Roller

Pillow cases, washed and ironed

Masking tape

1 Choose a selection of lace and ribbons to make up the pattern on your rolling pin. The lace that works best has a pronounced pattern and is quite thick.

2 Cover the rolling pin in PVA glue. Then wrap the lace around the rolling pin and press it into place. Cut away any excess so it fits neatly together. Repeat with any other lace or ribbon you have to create a wider pattern on the rolling pin.

3 Cover all the fabric with more PVA glue, making sure no fabric is left unglued. Try to make the lace and ribbon as straight as possible going around the pin, then leave to dry overnight.

4 Mix up some Wedgwood blue ink on the glass plate and roll it out to a medium consistency (see page 15). Ink up the rolling pin, making sure you cover the lace completely, and then do a couple of practice rolls on some scrap fabric so the ink soaks into the lace completely.

5 Place one of the pillow cases on a flat surface and tape down. Roll the rolling pin over the pillow case in one smooth firm go. Repeat with the other case and leave to dry.

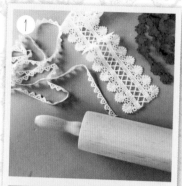

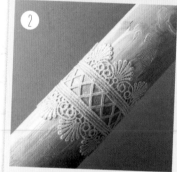

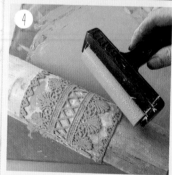

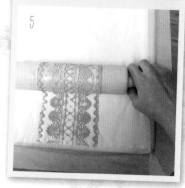

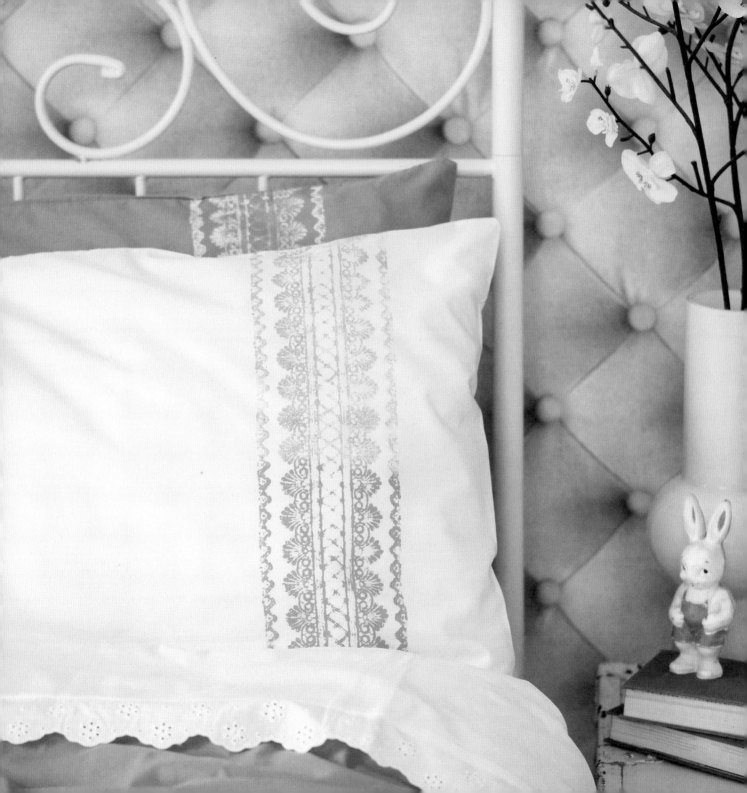

RIC RAC SCARF

Make a big print block using strips of ric rac braid and you can quickly cover large areas, such as on this scarf. Don't worry about the lines of braid being super straight – a bit wonky looks good too.

SUPPLIES

- 5mm thick foam board or thick card
- Scissors
- PVA glue
- 4m x 1cm wide ric rac braid
- Old paintbrush
- Rolling pin
- Yellow and white printing inks
- Palette knife
- Glass plate
- Roller
- 180 x 60cm plain cotton scarf or thin fabric
- Scrap of fabric for testing

EXTRA!

Make a gingham effect by printing one colour vertically and the other horizontally across the scarf.

Buy different widths of ric rac braid for a varied look.

PREPARE THE PRINTING BLOCK

1 Cut a piece of card so that its shorter sides are the same as the length of your rolling pin and its longer sides are the same as the width of your scarf or fabric.

2 Straight from the tube dribble 5–6 straight (ish) lines of PVA glue onto the card. Space the lines out quite widely. Have some travelling at slight diagonals and some straight.

3 Cut the ric rac braid into pieces the same length as the card. Place each piece onto the card over one of the lines of glue and run another line of glue over the top. Use an old paintbrush to dab the glue firmly over the ribbon and card, making sure the braid remains as straight as possible. Repeat until the card is full. You can use short pieces of ribbon to make up the full length of the card if you need to. Allow to dry fully – ideally overnight.

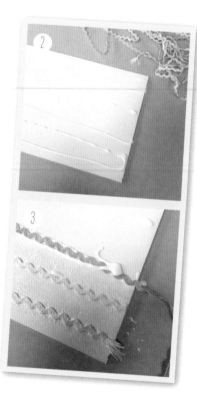

CONT >>>

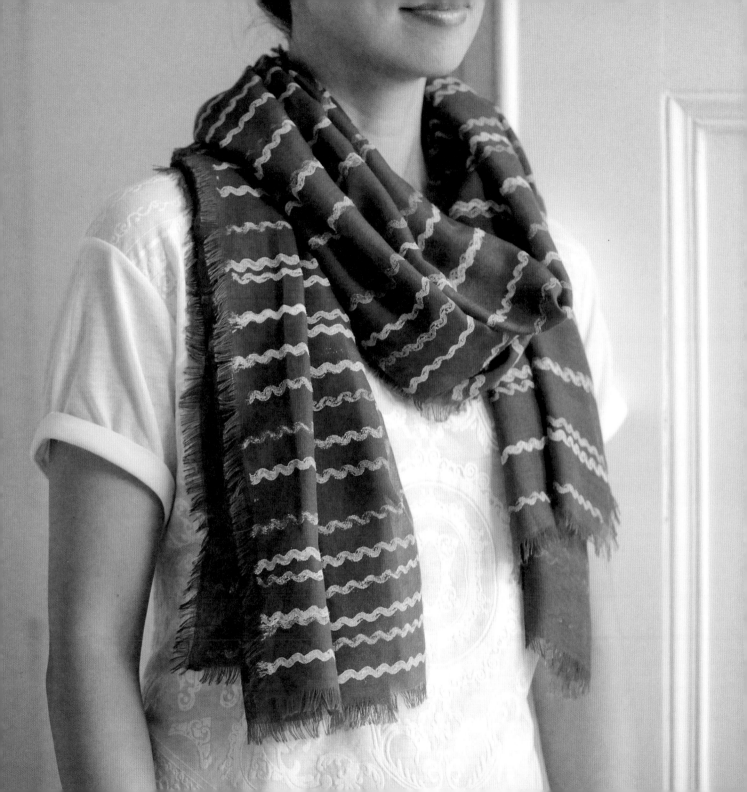

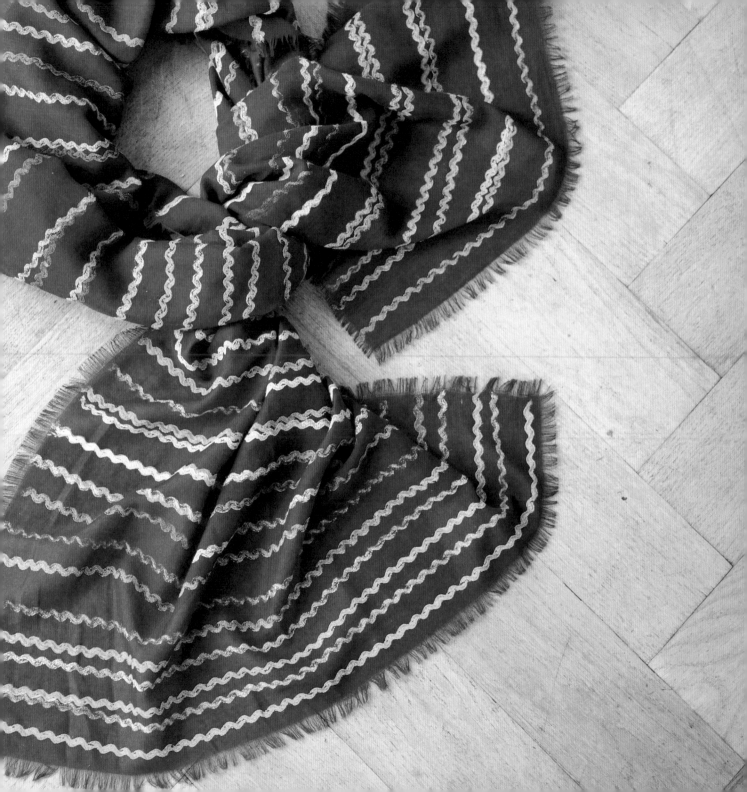

〉〉〉

4 Mix a little white ink with the yellow to make it paler on the glass plate and roll out to a thick consistency (see page 15). Roll the ink onto the ric rac block and use a tissue or rag to wipe away any ink that gets onto the cardboard. Pay special attention to the edges.

5 Do a couple of test prints on some old fabric first – this allows the ink time to get right into the ric rac giving a more consistent print and also allows you to work out how much pressure you have to apply. Place the block face down on the scrap fabric, use your hands to press it onto the fabric to stop it moving, then roll firmly over it a couple of times with the rolling pin. Carefully lift the block from the fabric making sure the fabric doesn't get all caught up beneath it.

6 Lay the scarf out on a flat surface. You may have to print it in a couple of sections unless you have a really long table!

7 Ink up the block and place it on to the fabric. Draw an arrow on the back of the card pointing in the direction of the majority of fabric. This will help you place the block down the right way every time.

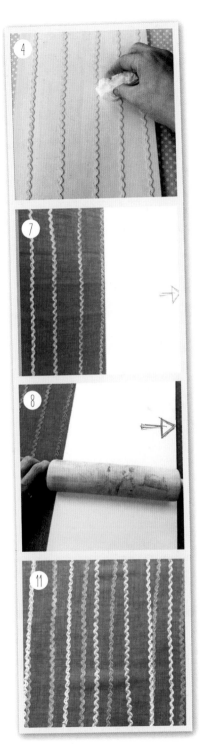

8 Use the rolling pin to apply even firm pressure across the block.

9 Carefully lift the block from the scarf. Repeat steps 8–9 until the whole scarf is covered.

10 Clean as much of the yellow ink from the block and leave it to dry, then ink it up with white ink.

11 You can either lay the block down in the same direction as you did with the yellow ink or flip it so the arrow is facing the other way. Whichever you choose, make sure you start with the block set slightly further up the fabric so you can see the first yellow line and make the ric rac lines staggered. Practise which way you like best with the scrap bit of fabric.

12 Print the whole scarf with the white ink and then leave it overnight to dry.

ALSO LOOKS GOOD ON

A simple white T-shirt: a blue print is an attractive alternative to the traditional Breton top.

Drum lampshade: run the ric rac stripes vertically around a lampshade (see page 64 for more instructions).

KNITTY NATTY CUSHION

This print miraculously transforms a sewn fabric cushion cover into a knitted cushion cover. If you have any leftover paint from house renovations, you can use it to make perfectly matched cushion covers for your newly decorated room.

TIPS BEFORE PRINTING

The kinds of knitted sweaters that work best for this project are cotton or not too fluffy woollen ones with a strongly pronounced stitch pattern – large cables are particularly effective. Scour jumble sales or charity shops for a sweater.

Mounting the knitting onto a piece of wood and covering it with PVA makes the stitches stand out more. The wood keeps the knitting in shape and you can apply an even pressure when printing.

1 Lay out the knitted sweater on a flat surface. Choose one 20cm square area that will work best as the print, then cut out. The cushion shown opposite uses two different sections of knitting, but it works equally as well with just one.

2 Cover the MDF with an evenly spread thick layer of PVA glue. Place one of the squares of knitting face down on the MDF and arrange it so the edges are neat and the sides straight. Knitting has a tendency to move around once cut, so you may have to trim the sides to neaten them. Press down the knitting into the PVA using the brush.

3 Spread more PVA on top of the knitting, then use the brush to ensure the adhesive covers the

CONT. >>>

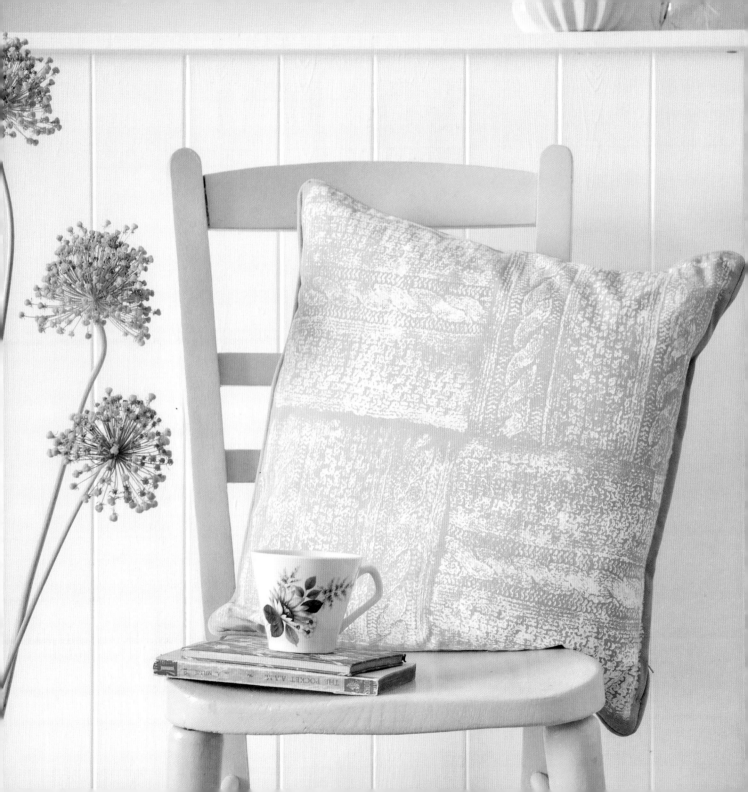

4　Use a firm downwards dabbing motion to completely coat the wool. Allow to dry overnight.

5　Place the cushion cover on the card.

6　Pour a quantity of paint onto the glass plate; a line about 15cm long and 5cm thick should be sufficient. Roll the paint out to coat the roller evenly, then roll up the knitted block. Coat the block evenly and until all of the knitting is covered.

7　Place the wooden block face down on one corner of the cushion cover and press firmly using the baren or rolling pin.

8　Place one hand on top of the block and cushion cover and slide the other under the card and flip the whole lot over. Be careful not to allow the fabric or wooden block to move. Remove the card and use the clean roller to press the fabric into the printing block. Carefully remove the cushion cover from the block.

9　Repeat steps 4–8 three more times in the other corners of the cushion cover. Rotating the block gives a patchwork effect. Allow the cover to dry before filling with a cushion pad.

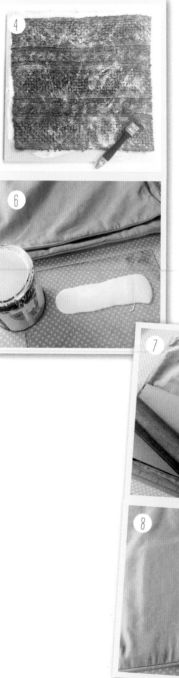

ALSO LOOKS GOOD ON …

Throws: try printing these blocks on a large piece of soft cotton or wool felt in a variety of colours to create a 'patchwork' throw.

Lampshades: follow the instructions on pages 64–7 to make a knit-print drum lampshade cover.

Upholstery: cover large areas of fabric with squares of this knit print, then use it to upholster dining chairs or to make a blind.

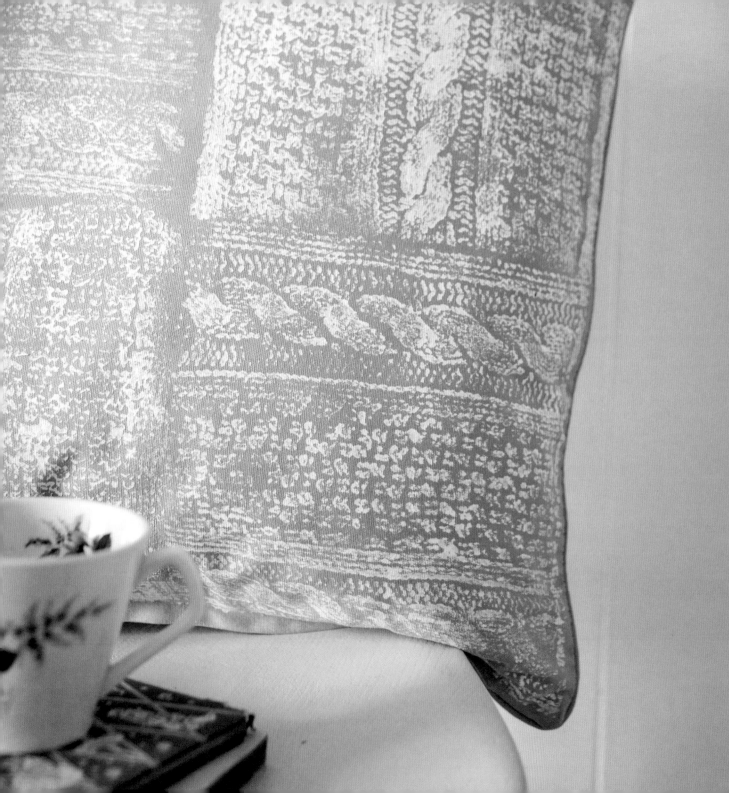

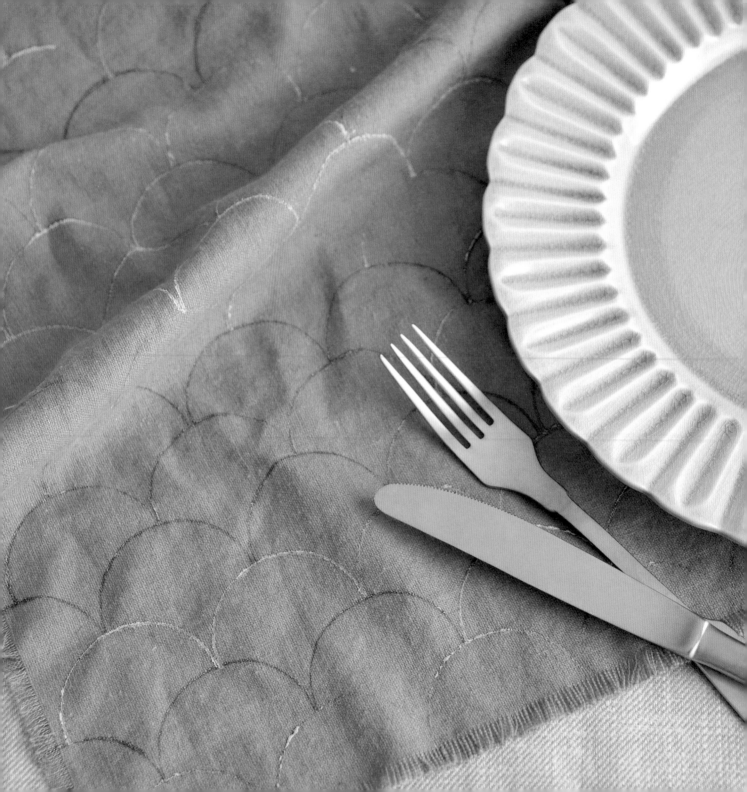

SHIMMERING SCALES NAPKINS

★ ★ ★ ★ ★ ★ ★ ★ ★ ★ ★ ★ ★ ★ ★ ★ ★ ★

Using three different shades of gold ink gives the printed scallops on these napkins an iridescent quality, like fish scales.

1sq m linen, washed and ironed

10cm round smooth edged plastic cookie cutter

Sharp knife

Gold and white printing inks

Palette knife

Glass plate

Roller

MAKES 4 NAPKINS

EXTRA!

Look out for different size scallop shapes that could be used for printing. The end caps of drainpipes are a great size for printing larger-scale scallops ideal for cushions or wallpaper.

Print three or four rows of scallops all around the base of a tablecloth to match your napkins.

TO PREPARE THE NAPKINS AND SCALLOP

1 Cut the linen into four 50cm squares, then fray the edges of the linen by pulling the loose threads away until there is a 5mm edge of fringing. If necessary, trim square again. Lay one napkin onto a flat surface.

2 Take the cookie cutter and place it face up on a flat surface. Press the knife down across the widest point of the cutter and cut straight down both sides of the plastic. Carefully cut away one half of the plastic until you are left with a semi-circular scallop shape.

CONT. >>>

>>>

TO PRINT ON THE NAPKINS

3 Prepare three shades of gold ink on the glass plate. One batch can be straight from the tube, the other two have different amounts of white mixed into them. For the lightest one, mix 2 parts white and 2 parts gold and for the mid shade mix 1 part white to 3 parts gold. Mix each one well with the palette knife and spread out quite thickly on the glass.

4 Start printing the napkin. Place the cookie cutter onto one shade of the gold, making sure there is a nice even coverage of ink on the scallop edge.

5 Place the scallop on the bottom left of the napkin and press down well. Carefully remove the scallop, ink up again and repeat, placing the scallop so it is touching the first one. After about three prints, change to the mid colour of gold and print a few more, then use the lightest colour.

6 Repeat until the first row of scallops is completed. Print row two by starting the scallop at the highest point of the first scallop in the first row. You will see the fish scale pattern begin to build up.

7 Complete this row by printing two half scallops at either end. Again change the colour of the ink every so often. Try to do this in a random way, sometimes printing just one of each colour and sometimes printing a run of three or four in one colour. In this way, a lovely undulating pattern of light and shadow builds up. Continue printing the rows until the whole napkin is filled.

8 Repeat with each napkin and allow them to dry overnight.

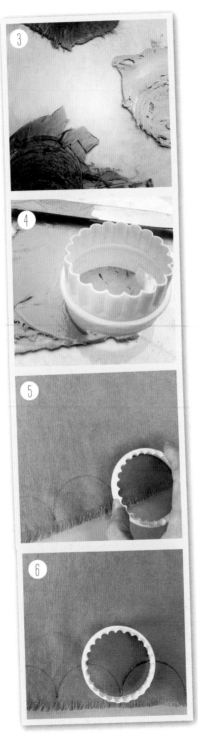

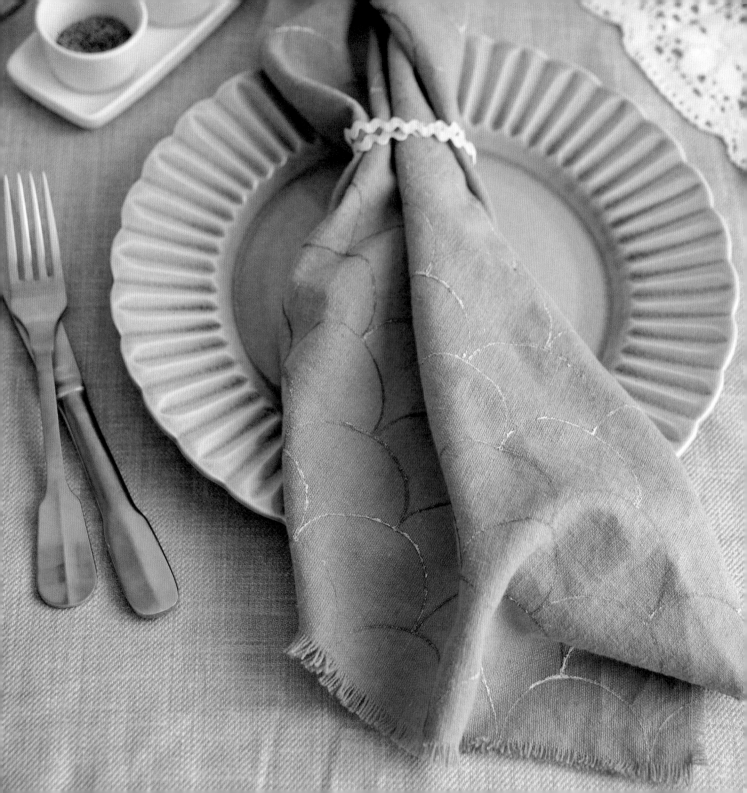

LAZY LINO PRINTS

When I was younger I spent many hours warming brittle pieces of lino on a radiator before they were soft enough to scoop out intricate patterns, or I would chisel into MDF (and the tips of my fingers) to make wood cuts. Nowadays, block printing has got a lot more finger friendly with the arrival of safer, softer printing materials. All the projects in this chapter use a thin polystyrene sheet called Safeprint foam, which is easy to cut with a knife or scissors and so easy to mark with a pencil. The effects you get can be just as intricate as a traditional lino or woodblock print, but in about a tenth of the time. It is also relatively cheap, so it doesn't matter if your pencil slips or you cut away the wrong piece, as you can just start again and be ready to print in no time.

• Bow Shoes • Nordic Forest Lampshade
• Nordic Forest Bag • Owl Family Notebooks
• Mrs Hare and Family Tote Bag • Mrs Hare T-shirt
• Mushroom Mayhem Cushion • Toadstool Cushion
• Bloomin' Marvellous Storage Boxes
• Rainy Day Brolly • Circus Letter Wooden Postcards

BOW SHOES

This is a quick and cute way of making a boring pair of canvas shoes fun and unique. You could also make smaller bows and print over the whole shoe.

SUPPLIES

Pencil

Safeprint foam sheet

Masking tape

Cutting mat

Craft knife

Metal ruler

Thin cardboard

Shoes

Turquoise printing ink

Glass plate

Roller

TO PREPARE THE PRINTING BLOCK

1 Using the template on page 117 and following steps 1–5 on pages 16–17, prepare a Lazy Lino bow. As you are printing onto a curved surface it is easier not to stick the bow to a Perspex block.

TO PRINT ON THE SHOES

2 Make two rough semicircles from the cardboard to place inside the toes of your shoes. This gives a firmer base to print onto.

3 Squeeze some of the turquoise ink onto the glass plate and roll it out to a fine consistency (see page 15). Roll the ink onto the Lazy Lino bow.

4 Carefully place the bow in position on the toe of the shoe.

5 Press down firmly on the Lazy Lino. You may find it helps to put one hand inside the shoe and press up from below. Make sure you press firmly and evenly over the whole bow.

6 Gently peel the bow away from the shoe. Repeat steps 2 to 6 on the other shoe. Leave overnight to dry fully.

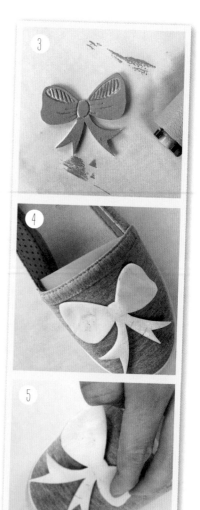

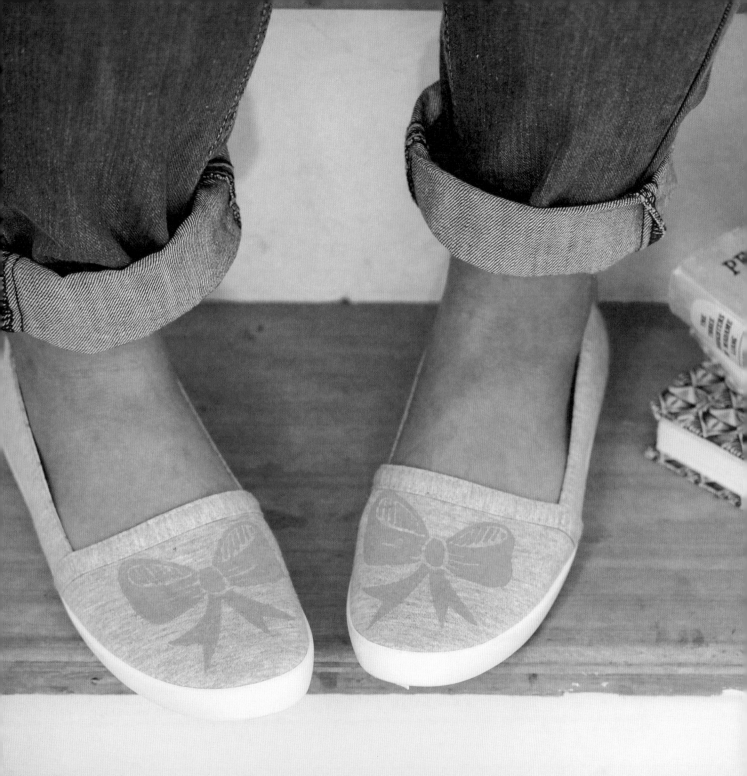

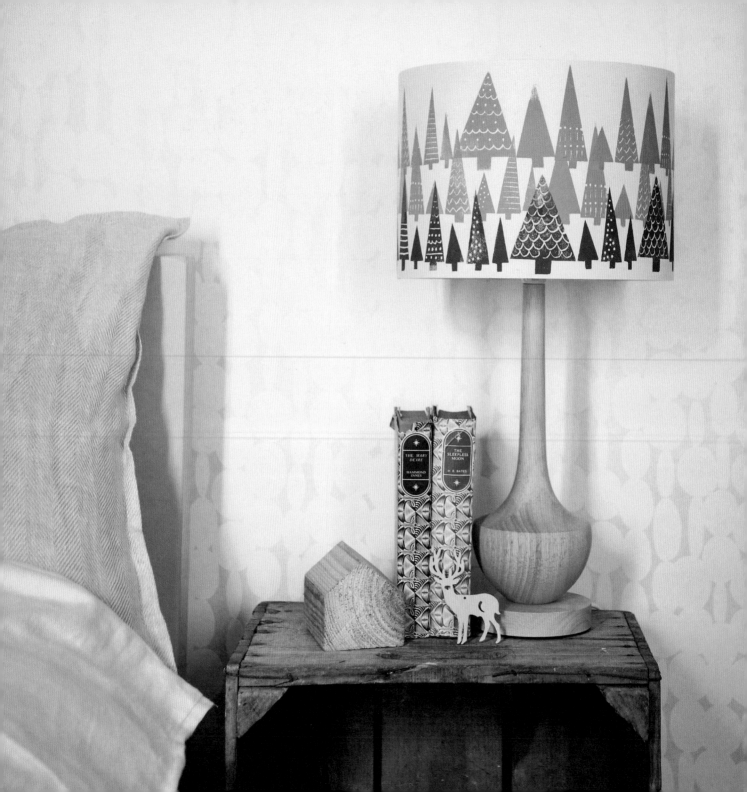

NORDIC FOREST LAMPSHADE

This lampshade design is inspired by the misty Scandinavian conifer forests of Norway and Sweden, where the trees gradually fade into the sky. I love the magical way the trees light up when it is turned on.

SUPPLIES

Pencil

Safeprint foam sheets

Masking tape

Cutting mat

Craft knife

Metal ruler

Double-sided tape

Two Perspex blocks large enough to take 4 trees each

Flexible tape measure

Drum lampshade in chosen size and colour (a pale shade works best)

Sheet of A1 150gsm card

Beige, pink and brown printing inks (see pages 12–13 for colour mixing tips)

Palette knife

Glass plate

Roller

Damp cloth

Baren or rolling pin

TO PREPARE THE PRINTING BLOCKS

1 Using the templates on page 123 and following the instructions on pages 16–17, prepare two Perspex blocks with four trees on each.

TO PREPARE THE CARD FOR THE LAMPSHADE

2 Using the flexible tape measure, check the circumference and height of the lampshade. Cut out a rectangle of card to these dimensions but add 2cm all around.

3 Lay the rectangle of card horizontally on a flat surface.

TO PRINT ON THE LAMPSHADE

4 Mix up some beige ink on the glass plate and roll it out to a fine consistency (see page 15). Ink up the two tree blocks and wipe away any excess ink with a damp cloth.

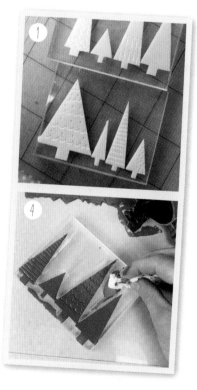

CONT. >>>

>>>

5 Begin printing at the top left of the card so the tips of the trees are about 5mm from the top. Print the first row of trees alternating the two blocks in a random pattern.

6 When this first row is finished, clean up the blocks with a damp cloth or cleaning wipe and pat dry.

7 Mix up the pink ink and roll out a thin layer. Ink up the blocks as before and print the next row of trees so they overlap the first by one third. Stagger the trees so that they sit in a different position to the first row. Again alternate the two blocks.

8 Clean up the blocks. Mix up the brown printing ink and print the final row as before. Allow to dry.

9 Using a craft knife and metal ruler, neatly trim the rectangle, removing the excess card. Take a strip of double-sided tape and run it along the vertical join of the lampshade from top to bottom. When the ink is dry, turn the card over and run a strip of tape along the short side on the right-hand side.

10 Remove the protective strip from the tape on the lampshade and the card. Place the shade in the middle of the card (making sure the trees are the right way up for your shade). Lift up the left-hand side of the card rolling it around the shade and fix the end to the tape on the shade.

11 Roll the other side of the card around the shade, keeping the card tight to the lampshade. Fix it in place using the tape on the card.

12 Place the completed shade onto your chosen lampbase and switch on.

ALSO LOOKS GOOD ON ...

Wrapping paper: try printing either rows and rows or just individual copses of trees.

Cushion covers: matching lampshade and cushion covers would look great in a sitting room.

Greetings cards: one block of these trees is the perfect size for a greetings card. For delightful Christmas cards, choose an appropriate colour and add a sprinkling of glitter.

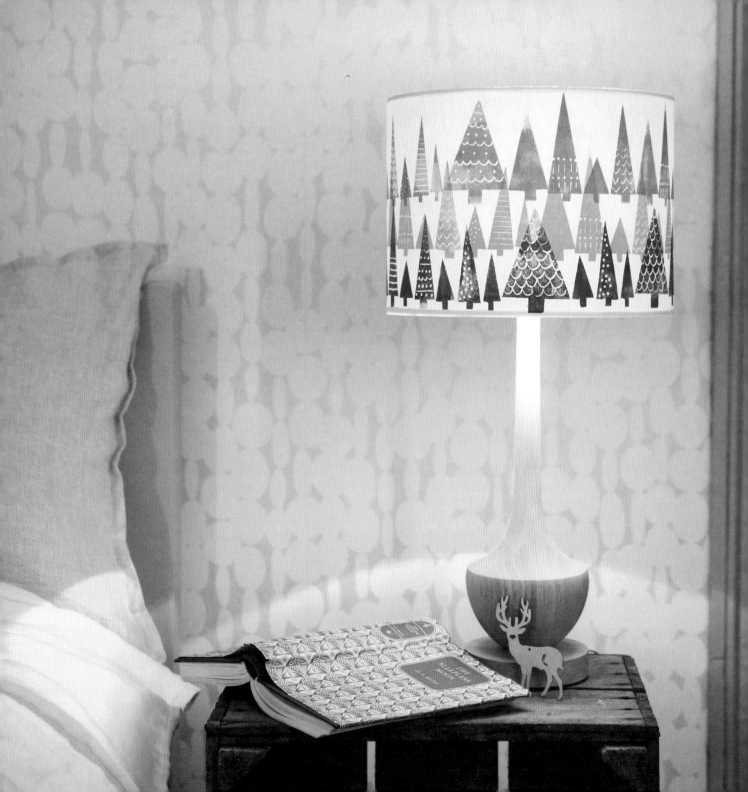

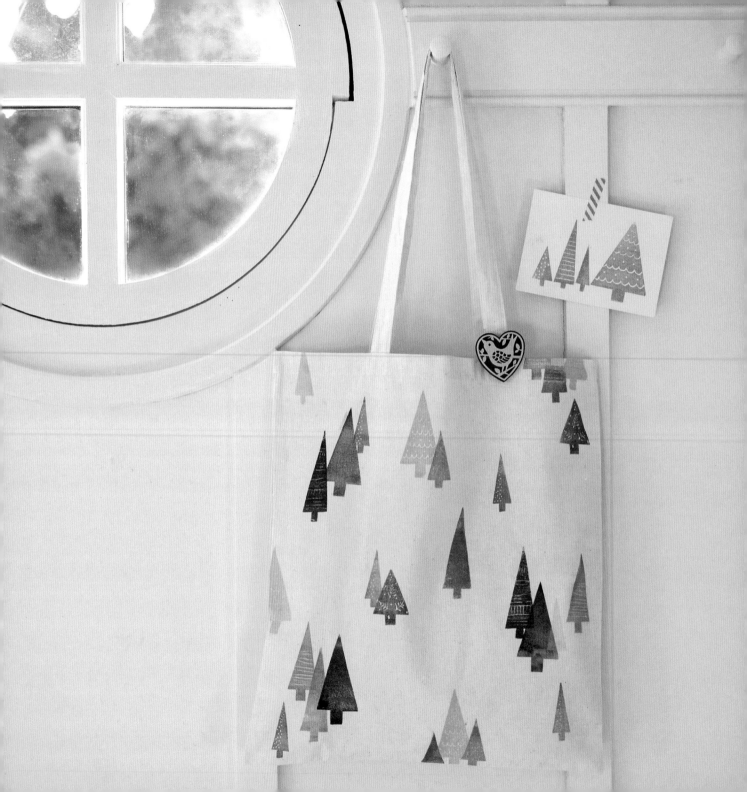

NORDIC FOREST BAG

The trees on this bag are the same ones as those used on the lampshade on pages 64–7. Instead of putting four trees on a Perspex block at one time, stick each one on an individual block. The bag in these pictures uses seven of the different designs of tree.

Lay the bag out on a flat surface and tape it down. Then mix up a light pink ink and print one tree randomly three or four times over the bag. Next mix up a dark grey and repeat with the second tree.

Repeat with a light grey, an olive, a pale olive and a bright pink colour, building up little copses of trees over the bag.

Leave the bag to dry overnight.

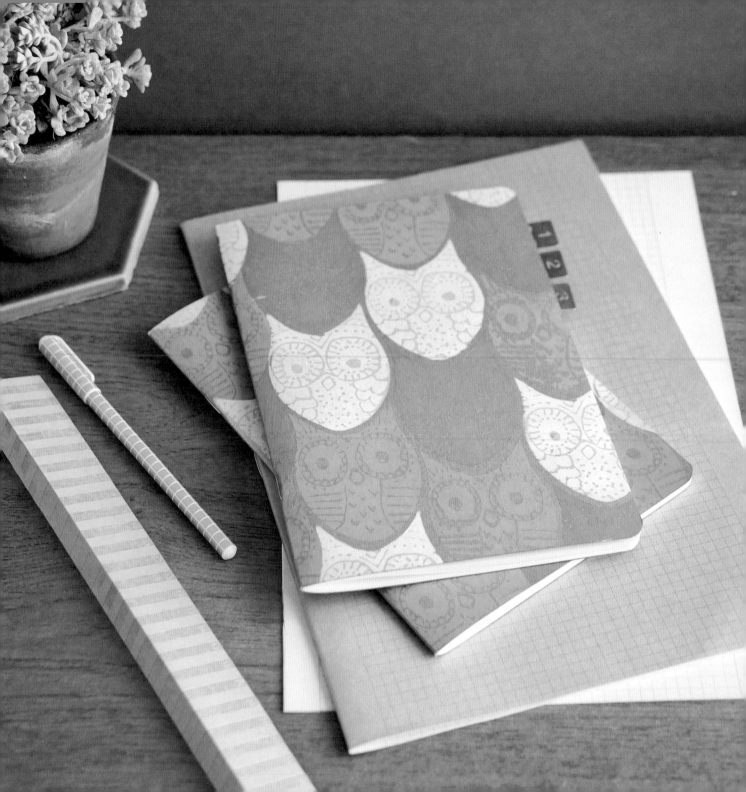

OWL FAMILY NOTEBOOKS

✳ ✳

I was inspired by the amazing tessellations by Escher when I was thinking up this project. Though my owls aren't quite as impressive as his illustrations, they do have a pleasing repeat pattern.

SUPPLIES

Pencil

Safeprint foam sheets

Masking tape

Cutting mat

Craft knife

Metal ruler

Double-sided tape

Perspex blocks

Turquoise, teal and pale turquoise printing inks (see pages 12–13 for colour mixing tips)

Palette knife

Glass plate

3 rollers

Damp cloth

Baren or rolling pin

Cardboard covered notebooks

TO PREPARE THE PRINTING BLOCKS

1 Using the templates on page 114 and following the instructions on pages 16–17, prepare three Perspex blocks with an owl on each. Use Owls A and B and only the solid block of Owl C.

TO PRINT ON THE NOTEBOOK

2 If you have three rollers roll out the three colours of ink on the same glass plate, this makes it quicker to print. Roll out the inks to a fine consistency (see page 15).

3 Do a couple of practice prints before you start on the notebooks (see steps 12–14 on page 18). Print Owl A in turquoise in the middle of the notebook.

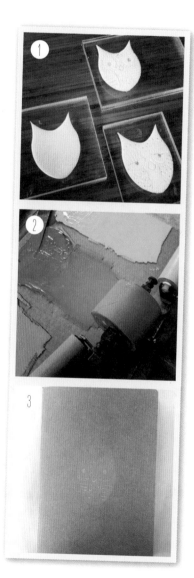

CONT. >>>

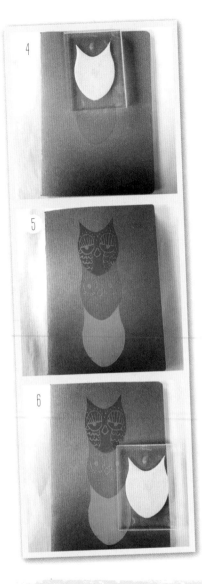

>>>

4 Print Owl B in teal and position him so that his tail is nestled between Owl A's ears.

5 Print the solid block of Owl C in the pale turquoise and nestle him beneath Owl A.

6 Start printing the second row of owls with Owl B. He should fit snugly in the right-hand curves created by Owls A and C.

7 Repeat steps 4–6 until the whole book is covered.

8 Leave the book to dry. Meanwhile, clean off any excess ink from Owl C then draw the overprint outline from page 114 onto it. Mix up some more teal ink and add a little white to it to make it paler. Use this to ink up Owl C again. Print over the solid print on the book. Leave to dry.

ALSO LOOKS GOOD ON ...

Kids T-shirts: enlarge the owl template and print one big owl in the middle of a T-shirt. You could print a back view of the owl on the reverse of the shirt.

Greetings cards: cut a branch shape and a leaf shape to give your owl something to perch upon on the front of a set of greetings cards.

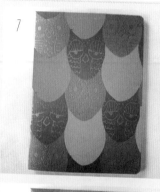

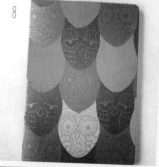

EXTRA!

To get the look shown in the main picture on page 70, print the owls with a slight border around each one. Just leave some space between each owl when printing. On smaller notebooks, use only one or two owls.

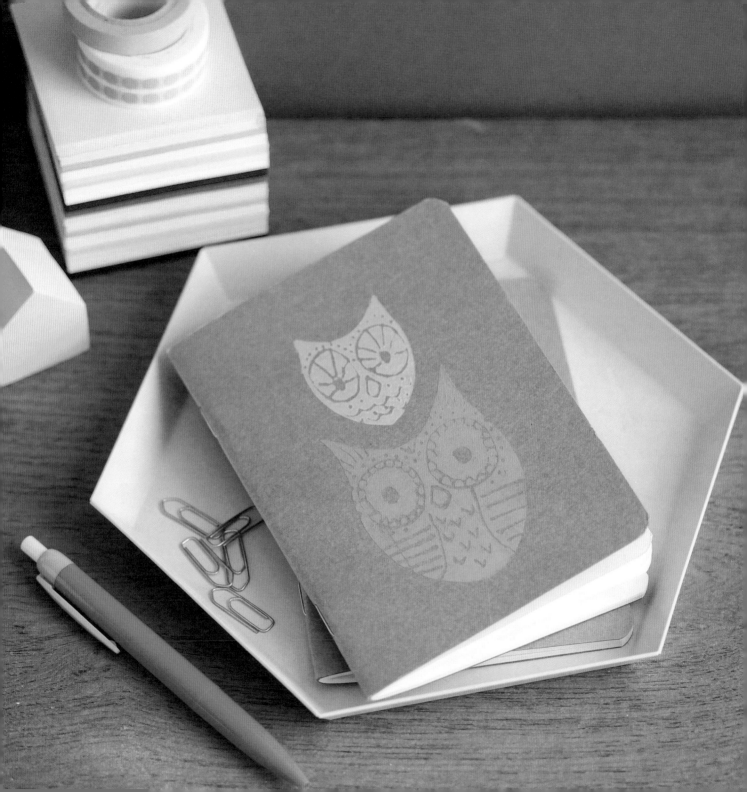

MRS HARE AND FAMILY TOTE BAG

✦ ✦

I used to cover my school notebooks with doodles like the ones decorating Mrs Hare and her children. They are very satisfying to draw. The hare shape looks great as a repeat pattern.

SUPPLIES

Pencil

1 x A3 Safeprint foam sheets

Masking tape

Cutting mat

Craft knife

Metal ruler

Double-sided tape

Perspex or wooden block

Grey, yellow and white printing inks (see pages 12–13 for colour mixing tips)

Glass plate

Roller

Damp cloth

Baren or rolling pin

Grey cotton tote bag, washed and ironed

Piece of card to put inside the bag (optional)

TO PREPARE THE PRINTING BLOCKS

1. Using the template on page 122 and following the instructions on pages 16–17, prepare the large hare block. After you have cut out Mrs Hare from the foam, you need to do the doodle pattern. You can either copy the pattern on the template using carbon paper (see page 14) or draw one freehand. Start by drawing a semi-circle from her armpit to her mid thigh. Surround this with a scalloped line.

2. Then working out from this line draw circles of dots, dashes, hearts… whatever takes your fancy until she is covered.

CONT. ⟩⟩⟩

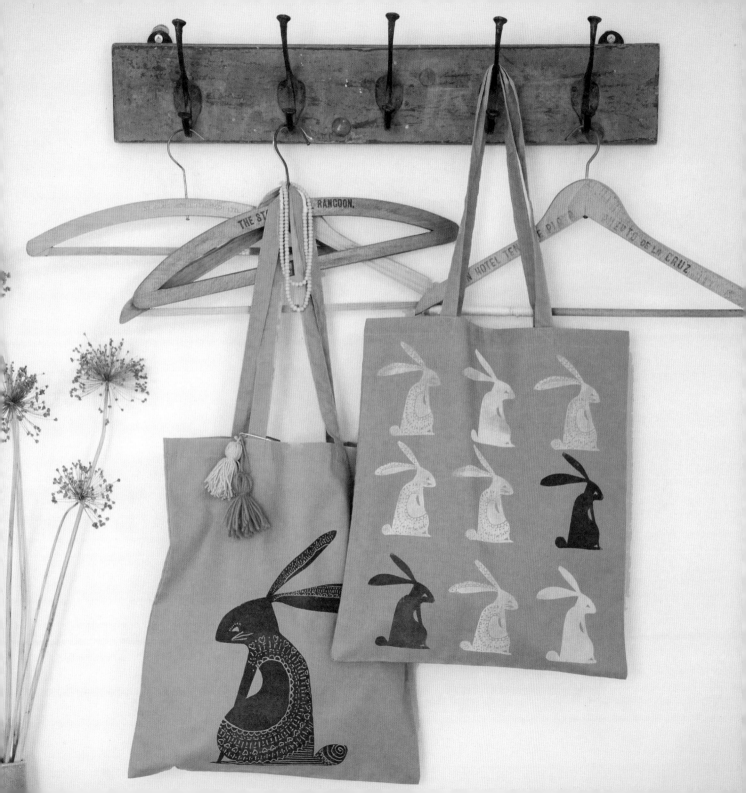

3 Repeat with her ears and finally draw in her nose and whiskers.

4 As Mrs Hare is quite large, you won't need a Perspex block to print her with. If you are going to be printing several of her, though, and you don't have a large enough Perspex block, you may want to fasten her to a block of wood to make her more substantial.

TO PRINT ON THE TOTE BAG

5 Mix up some grey ink on the glass plate (you will find that you need more ink than usual for this large print) and roll it out to a fine consistency (see page 15). Ink up the hare and make a couple of test prints. Use a rolling pin to apply an even pressure.

6 Place the tote bag on a firm flat surface. If the bag is made of thin material, place a piece of cardboard inside so the ink doesn't bleed through.

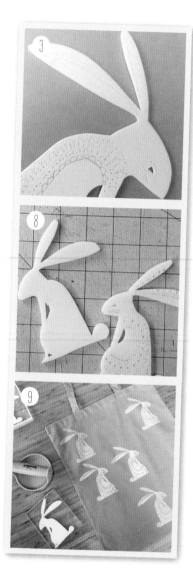

7 Place the hare in the middle of the bag about 3cm from the base and print (see steps 12–14 on page 18).

8 Allow Mrs Hare to dry. Meanwhile, make up three of the smaller hares for the reverse of the bag, following steps 1–4 and using the smaller outline on page 122. You need three blocks, one for each colour of paint. Add the decorative patterns to one of them.

9 Print the patterned hare first in white, then print solid yellow hares, followed by grey hares. Use a baren or rolling pin to get an even pressure over the block. Allow to dry overnight.

ALSO LOOKS GOOD ON ...

T-shirts: the large hare fits perfectly on the front of a T-shirt or print a random pattern of little ones.

A wall frieze: a higgledy piggledy line of these mini hares would make a cute frieze around the wall of a baby's room. Or print several onto card and cut them out to make a mobile.

MRS HARE T-SHIRT

Mrs Hare is the perfect size for a T-shirt. Before you print, make sure you wash and iron the T-shirt.

To work out the best placement for the hare, put on the T-shirt and hold the foam block in front of you in a mirror. Move her around until she looks like she's in the right place.

Make a little mark on the T-shirt with tailor's chalk or a pencil where you want the top of her ears to be. Lay the shirt on a flat surface, taping down the shoulders and bottom of the shirt.

Ink up Mrs Hare as in step 5, opposite, and print onto the shirt. Use a clean rolling pin to apply an even pressure.

MUSHROOM MAYHEM CUSHION

The slightly larger scale of these mushroom motifs and the fact that large areas of the foam is cut away gives a traditional rustic woodcut feel to the prints.

SUPPLIES

Pencil

Safeprint foam sheets

Masking tape

Cutting mat

Craft knife

Metal ruler

Double-sided tape

Perspex blocks

Cushion cover, washed and ironed

Piece of card to put inside the bag (optional)

Brown and white printing inks (see pages 12–13 for colour mixing tips)

Palette knife

Glass plate

2 rollers

Damp cloth

Baren or rolling pin

TO PREPARE THE PRINTING BLOCKS

1. Using the templates on page 115 and following the instructions on pages 16–17, prepare the Perspex blocks with a mushroom on each. If you don't have a Perspex block large enough for Mushroom B, don't worry as this piece of foam is big enough to print from directly.

2. Make sure you prepare two blocks for mushrooms A and C as these have a white base and then a brown outline printed over the top.

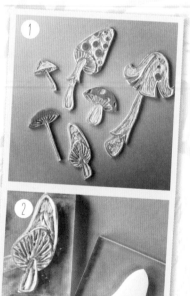

CONT. >>>

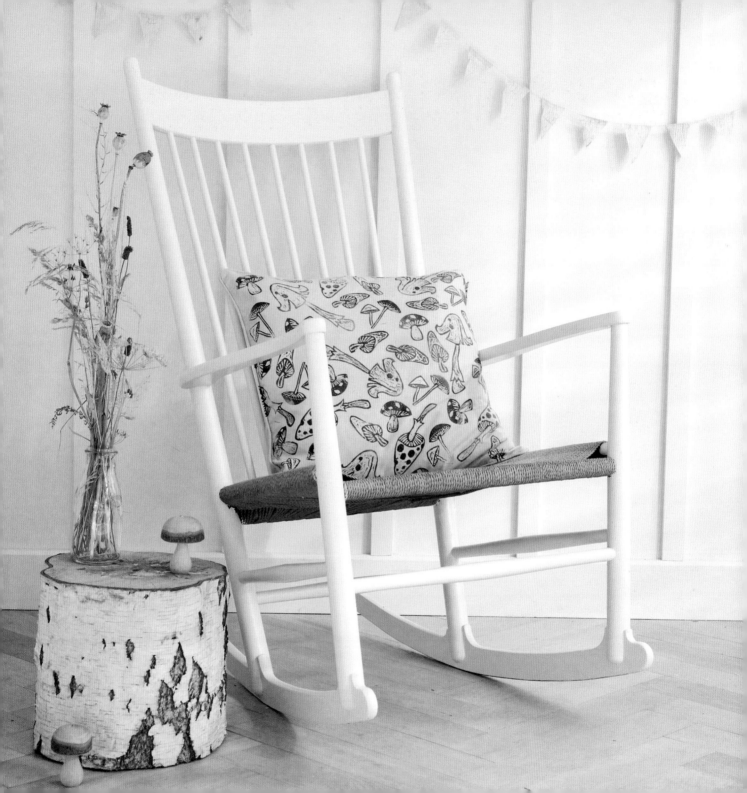

〉〉〉

TO PRINT THE CUSHION COVER

3 Lay the cushion cover out on a
flat surface. If the cover is thin,
place a piece of card inside so
the ink doesn't soak through.

4 Mix up some brown ink on the
glass plate and roll it out to
a fine consistency (see page
15) and begin printing with
Mushroom E (see steps 12–14
on page 18). Print three or four
mushrooms over the cover,
making sure they are all at
different angles to each other.

5 Start building up a pattern
around the mushrooms filling
in the spaces between larger
mushrooms with smaller ones.

6 Roll out the white ink to a fine
consistency and print the base
colour for mushrooms A and C.

7 Don't worry about keeping
all the mushrooms contained
within the cushion cover, print
some over the sides.

8 When you have filled the cover
the white ink will have dried, so
now you can print the brown
outline block for mushrooms A
and C over the top of the white.

9 Allow the cover to dry overnight
before you fill it with a cushion
pad and pop it on a chair.

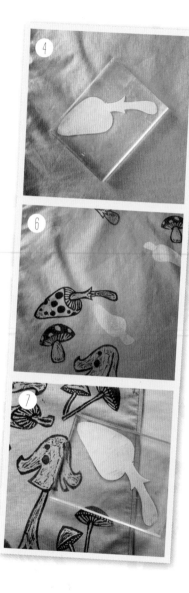

ALSO LOOKS GOOD ON …

A lampshade: print a random
pattern of mushrooms on a
lampshade (see pages 64–7)
to make a matching set.

The base of a wall: clusters
of mushrooms around the base
of a wall in a summerhouse or
hallway would add interest to
an otherwise plain wall.

**Notebooks and greetings
cards:** individual mushrooms
printed on stationery make an
attractive gift set.

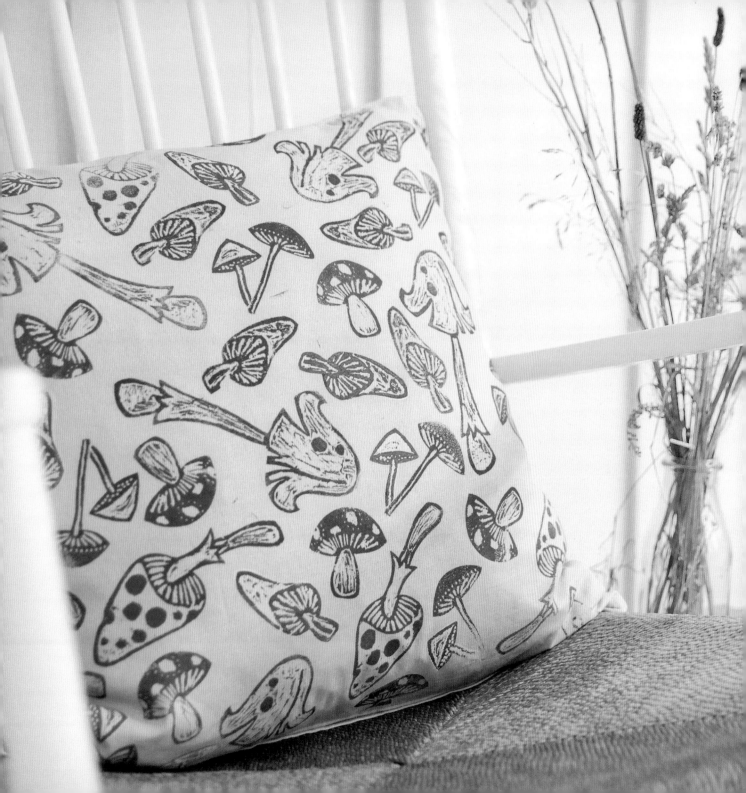

TOADSTOOL CUSHION

In this project I show you how to overprint different blocks to build up a multi-coloured image. I have used two shades of pink together with red, white and brown, but the end result would be equally effective in just red, white and brown.

SUPPLIES

Pencil

Safeprint foam sheets

Masking tape

Cutting mat

Craft knife

White, pink, red and brown printing inks (see pages 12–13 for colour mixing tips)

Glass plate

2 rollers

40 x 40cm cushion cover, washed and ironed

TO PREPARE THE PRINTING BLOCKS

1 Using the templates on pages 120–1 and following the instructions on pages 16–17, prepare the toadstool blocks. As the toadstool pieces are all quite large, you don't need Perspex blocks to print with.

2 Make sure you have a separate piece of foam for each toadstool colour and its outline.

TO PRINT ON THE CUSHION COVER

3 Squeeze some white ink on the glass plate and roll it out to a fine consistency (see page 15). Print the three white toadstool stalks. Use a clean roller to apply even pressure over the back of the foam.

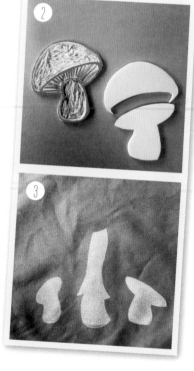

CONT. >>>

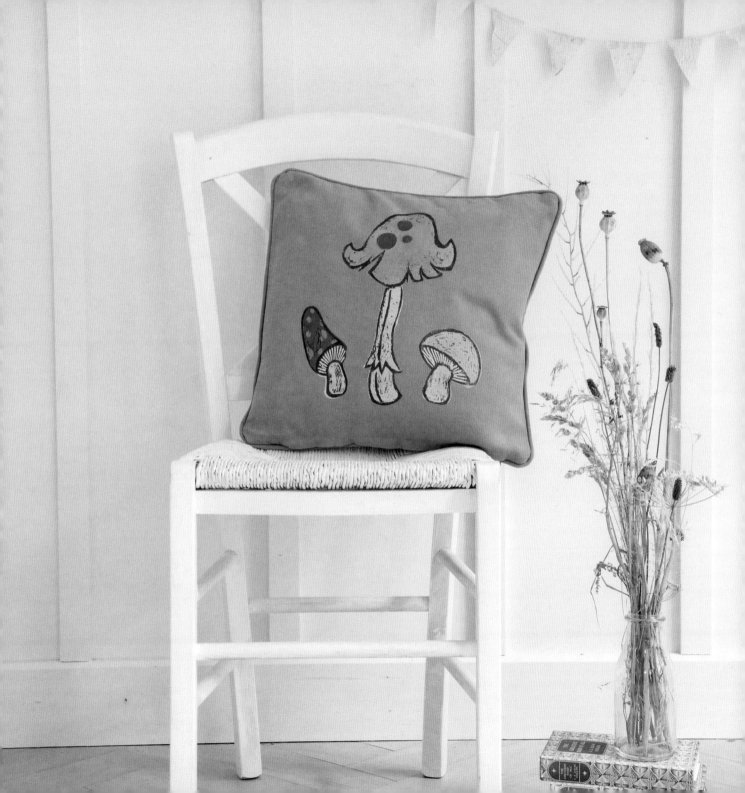

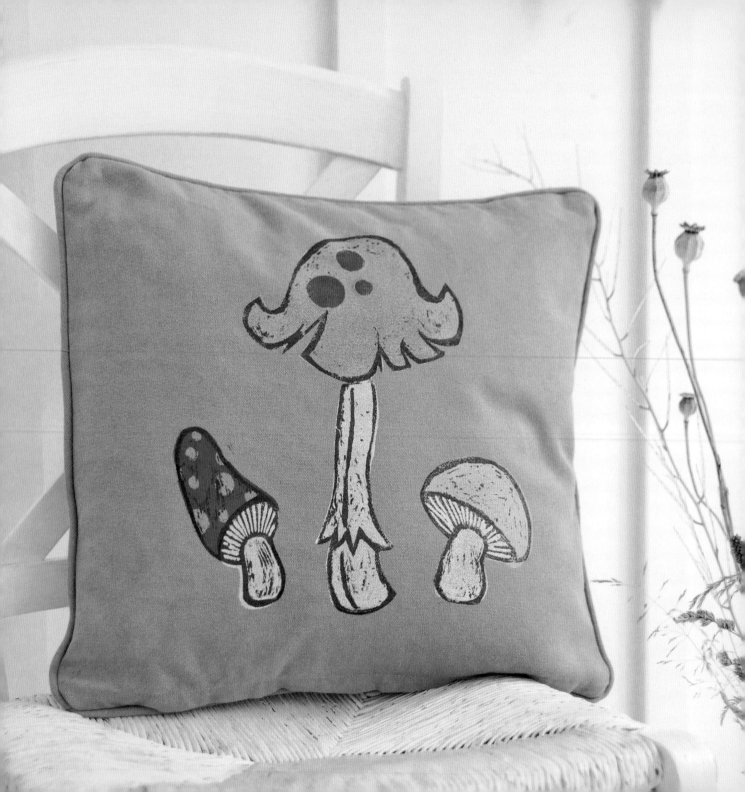

〉〉〉

4 Add a little red to the white ink and mix it together well to make a pale pink for the cap of toadstool C. Roll the ink onto the foam and carefully position it in place above the white stalk.

5 Add a little more red to the ink to make a slightly darker pink. Use the ink to repeat step 4 for the cap of toadstool B.

6 Repeat step 4 for the cap of toadstool A and the spots of toadstool B, but this time use a neat red ink for the colour.

7 Ideally allow these colours to dry before you print the outlines.

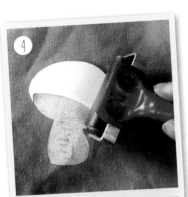

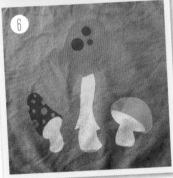

8 Mix up some brown ink and roll it out to a fine consistency, then roll the ink onto one of the toadstool outlines. Carefully position the foam on top of the coloured ink shapes and apply an even pressure to the back of the foam.

9 Remove the foam block to reveal the toadstool outline. Repeat for other toadstools.

10 Allow the cover to dry overnight before you fill it with a cushion pad and admire your work.

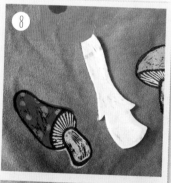

ALSO LOOKS GOOD ON ...

A raincoat: use a single image on each pocket and, if you want to go the whole hog, print a pattern all around the hem. For a larger repeat pattern, mix these toadstools with the mushrooms on pages 78–81.

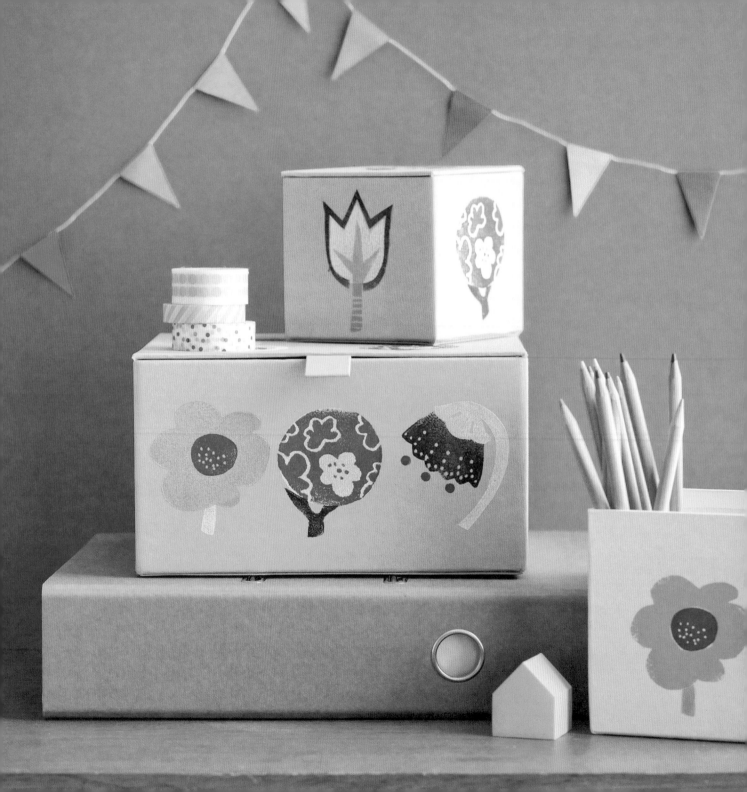

BLOOMIN' MARVELLOUS STORAGE BOXES

These pretty flowers will liven up any plain storage or gift box. Give old shoeboxes a new lease of life or spruce up your kitchen bread bin and tins.

SUPPLIES

Pencil

Safeprint foam sheets

Masking tape

Cutting mat

Craft knife

Double-sided tape

Perspex blocks

White, lilac, red and grey printing inks (see pages 12–13 for colour mixing tips)

Glass plate

Roller

Damp cloth

Glass plate

Baren or rolling pin

Plain storage boxes

TO PREPARE THE PRINTING BLOCKS

1 Using the templates on page 117 and following the instructions on pages 16–17 prepare the flower blocks ready for printing.

2 Use a pencil to engrave the patterns on the foam pieces.

3 Mount the four foam pieces that are marked to be printed in white onto Perspex blocks.

CONT. >>>

»»

TO PRINT ON THE STORAGE BOXES

4 Squeeze some white ink onto the glass plate and roll it out to a fine consistency (see page 15). Ink up each Perspex block and print on to the top of the box and around the sides, or wherever you fancy (see steps 12–14 on page 18).

5 Remove the pieces of foam from the Perspex blocks and clean them up (see page 14). Then mount the two flower pieces that are going to be printed in lilac. Mix up the lilac ink, ink up the blocks and print the lilac areas.

6 Repeat step 5 for the three grey pieces of the flowers.

7 Then repeat step 5 for the two red pieces of the flowers. Use a pencil with a rubber on the end to make the small red dots for the grey flower. Leave to dry.

ALSO LOOKS GOOD ON ...

Greetings cards: print one flower on each card to make pretty sets to give as presents

Office supplies: liven up your office space with some bright blooms. Print a random repeat pattern over plain ring and box files, folders and notebooks.

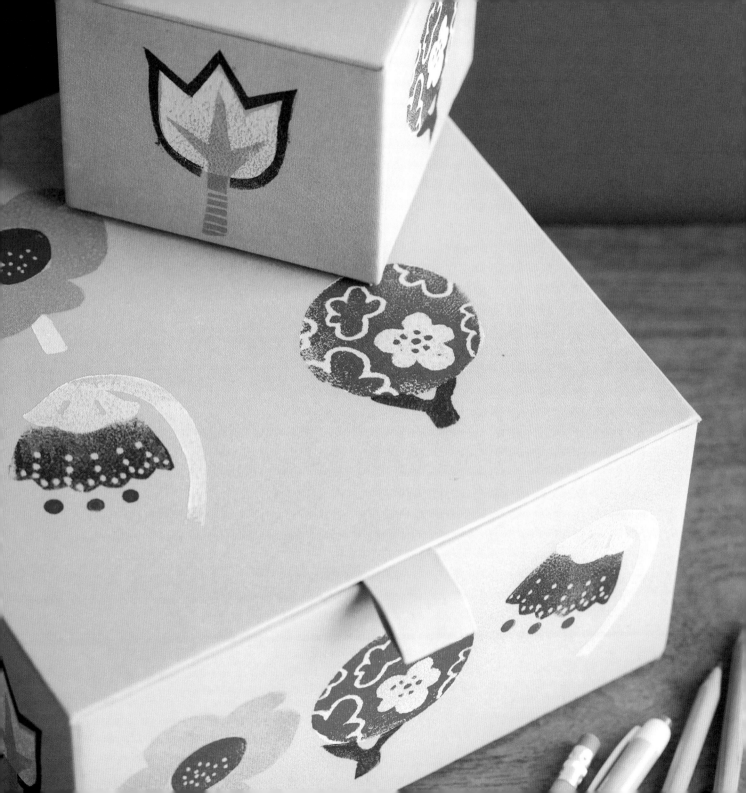

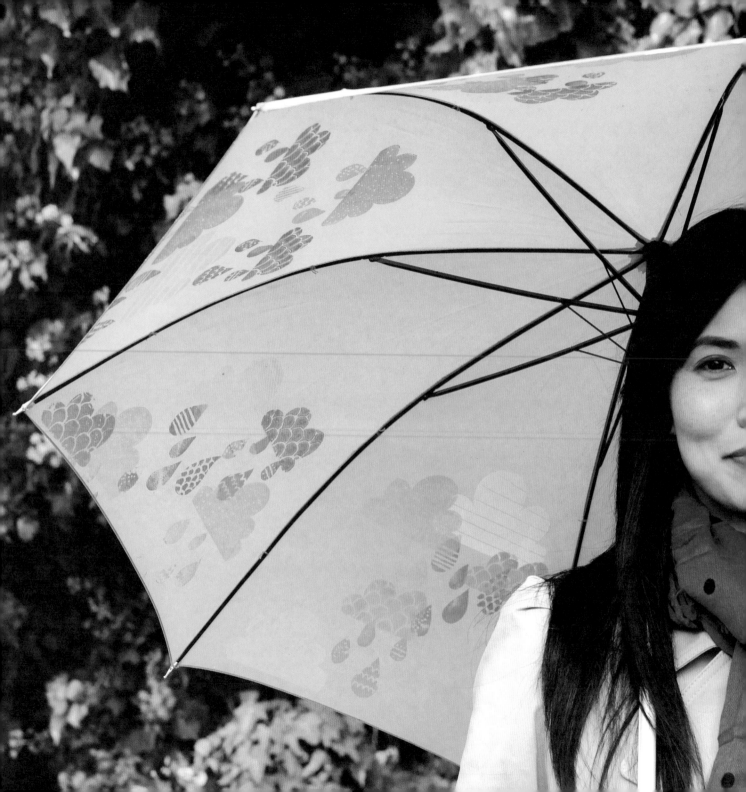

RAINY DAY BROLLY

★ ★ ★ ★ ★ ★ ★ ★ ★ ★ ★ ★ ★ ★ ★ ★ ★

I always think it's sad that most brollies have the pretty print only on the outside so the person hiding beneath it doesn't get to see it. This brolly has prints on both sides, so everyone's a winner.

SUPPLIES

Pencil

Safeprint foam sheets

Masking tape

Cutting mat

Craft knife

Double-sided tape

Perspex blocks

Plain umbrella

White, turquoise and silver printing inks (see pages 12–13 for colour mixing tips)

Palette knife

Glass plate

Roller

Baren or rolling pin

TO PREPARE THE PRINTING BLOCKS

1 Using the templates on page 116 and following the instructions on pages 16–17, prepare three Perspex blocks with a cloud on each.

TO PRINT THE BROLLY

2 Squeeze out some white ink on the glass plate and roll it out to a fine consistency (see page 15). Ink up the first cloud.

3 Open your brolly (if you're superstitious you may want to do this bit outside!) and print the cloud on the inside of one of the segments (see steps 12–14 on page 18). Repeat in each of the segments, printing the cloud in a different place each time.

CONT. >>>

〉〉〉

4 Repeat with the other two clouds. Mix up a fine consistency of pale turquoise for one cloud and a silvery blue for the other. Again print the clouds in different positions on each segment, sometimes overlapping them. Leave the brolly open to dry.

5 Prepare the raindrops. To ensure the raindrops fit the cloud, print one of each cloud onto a piece of scrap paper. Then cut out the raindrops from the foam using the templates on page 116. Stick double-sided tape to the back of each of them and place the raindrops for one of the clouds face down onto the paper in the position you want them to be printed in.

6 Place a Perspex block on top of the raindrops and press down so they stick to the block.

7 This time working on the outside of the umbrella, print the raindrops adjacent to their corresponding cloud (you will be able to see the cloud clearly through the fabric).

8 Repeat steps 5–7 with the other two clouds and their raindrops. Leave the brolly open to dry.

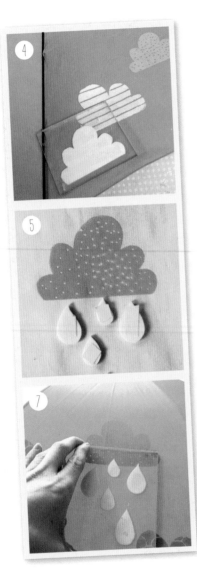

ALSO LOOKS GOOD ON ...

Notebooks: print just one cloud in a repeat pattern over both the front and back of the book.

Cushion covers: if you cut out a circle and print it in yellow, you can make a lovely rain and shine pattern for the centre of a cushion cover.

Duvet set: over-sized clouds make a lovely repeat pattern across a duvet cover. You could then also print a large yellow sun on a pillowcase to make a cool bedding set.

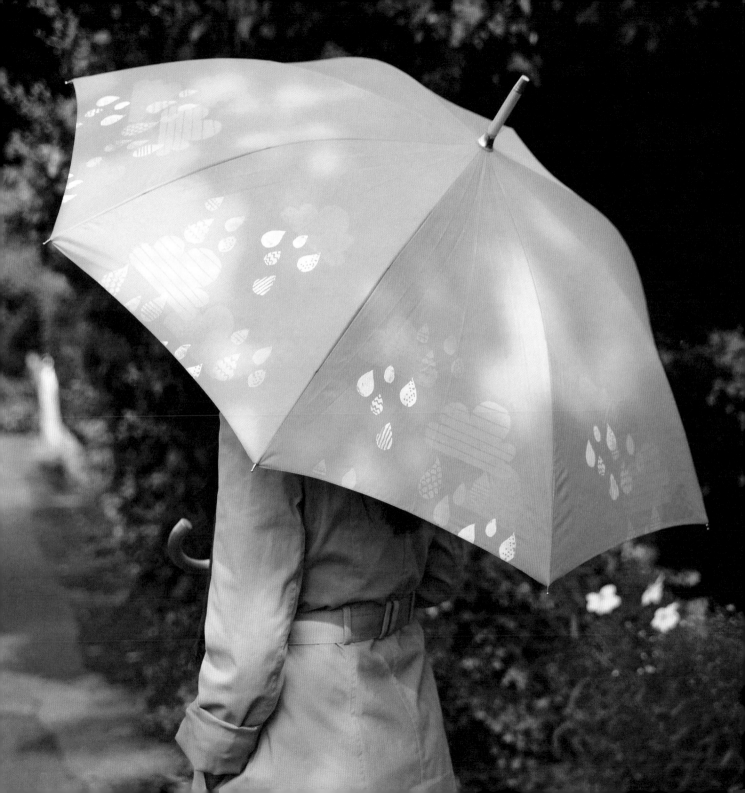

CIRCUS LETTER WOODEN POSTCARDS

SUPPLIES

Pencil with an eraser on the end

Safeprint foam sheets

Masking tape

Cutting mat

Craft knife

Double-sided tape

Perspex blocks

15 x 10cm wooden postcards

Assorted colours of printing inks (see pages 12–13 for colour mixing tips)

1 roller for each colour ink

Glass plate

Assorted colours of rubber stamp inks

Star-shaped rubber stamp (optional)

EXTRA
You can buy blank wooden postcards online, but they are expensive. For a cheaper alternative, ask a timber merchant to cut several 15 x 10cm rectangles from a sheet of 5mm plywood. Sand down the edges until they are smooth.

I adore circus lettering and these initial postcards are a lovely modern take on personalised stationery. These cards make great wedding invitations or baby announcements.

TO PREPARE THE PRINTING BLOCKS AND WOODEN POSTCARDS

1 Choose your preferred letters from the templates on pages 124–5 and, following the instructions on pages 16–17, cut the letters from the foam and fix each one to a Perspex block. You need two pieces of foam for each letter: one for the three-dimensional effect and a smaller one to print over the top.

2 Print a square of base colour on the wooden postcard by rolling out the desired colour ink. Push the roller over the wood. Allow the ink to dry.

TO PRINT ON THE POSTCARDS

3 Mix your chosen colour for the larger letter block on the glass plate and roll it out to a thin consistency (see page 15). Transfer the ink onto the letter.

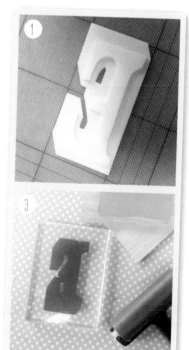

CONT. >>>

>>>

4 Place the Perspex block centrally on the wooden postcard. Roll over the block with a clean roller to apply a firm and even pressure. Carefully remove the black and allow the ink to dry.

5 Repeat steps 2 and 3 for the second slightly smaller initial using a contrasting colour. Make sure you position this block in the correct place on top of the first initial. To add stripes or any other patterns inside the letters, use a pencil to draw directly onto the foam (see page 14 for further instructions).

6 To create the decorative dots around the edges of the letters, use an eraser from the top of a pencil and ink from a rubber stamp pad. Alternatively, further decorate the postcards using small shop-bought rubber stamps or cut your own shapes from the foam sheet.

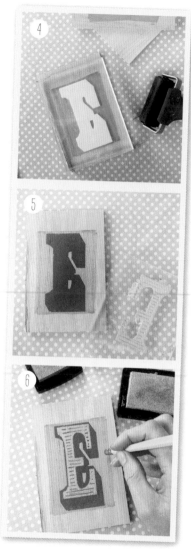

ALSO LOOKS GOOD ON ...

Greetings cards: if you can't easily get hold of or make your own wooden postcards then blank greetings cards work just as well. To print onto a pair of initials onto one card, just cut each letter slightly smaller than suggested for this project.

Framed prints: use a selection of letters printed on to art paper to make up favourite words or names.

Cushion covers: enlarge an initial to fill a cushion cover and print directly on to the fabric.

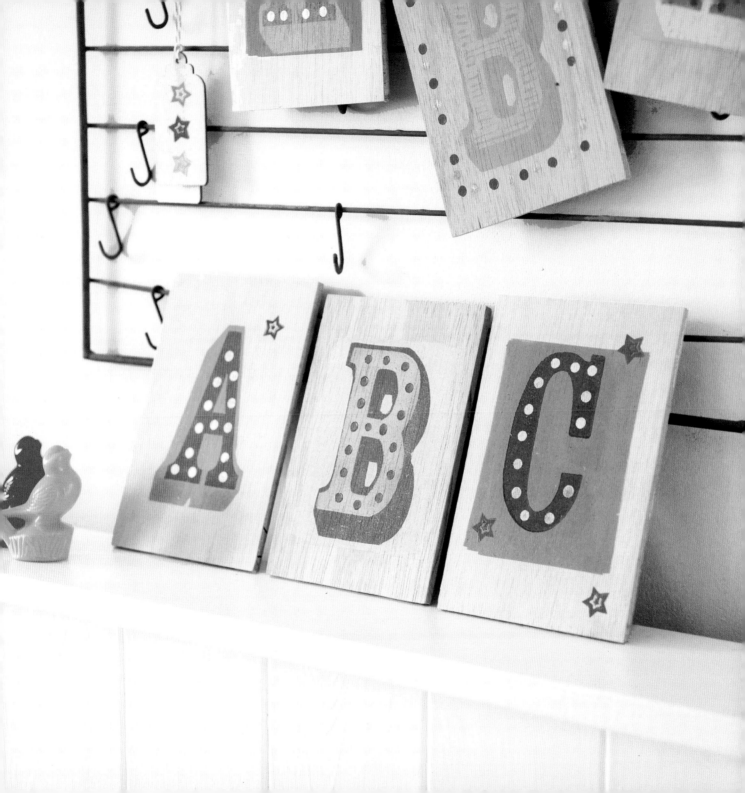

OTHER PRINTING TECHNIQUES

You don't just have to use a found object or cut
a block to make beautiful patterns and prints.
This chapter has projects that use the sun, a ball
of string, bleach and PVA glue to make a variety
of effective and professional-looking printed
products. One of my favourite projects in the
book is in this chapter, the Bleach Beach Towels
(see page 104). I was so pleased with
the results that every towel I own now has
some sort of print on it.

• Giant Ginkgo Leaf Blind • Bleach Beach Towels
• Which Way? Pencil Case • Sunflower Tablecloth

GIANT GINKGO LEAF BLIND

★ ★ ★ ★ ★ ★ ★ ★ ★ ★ ★ ★ ★ ★ ★ ★ ★ ★

Two different techniques are used to make the blocks for this blind. One gives a solid leaf print and the other shows the more delicate veins in the leaf by using good old fashioned string stuck to the foam sheet.

SUPPLIES

Pencil

1 x A3 safeprint foam sheet

Masking tape

Cutting mat

Craft knife

Thick card

PVA glue

Old paintbrush

String or garden twine

Scissors

Green, yellow and white printing inks
(see pages 12–13 for colour mixing tips)

Glass sheet

Roller

Rolling pin

White or pale colour roller blind

TO MAKE THE PRINTING BLOCKS

1 Using the templates on pages 118–19 and following the instructions on pages 16–17, cut two leaf shapes from the foam sheet.

2 Choose one of the templates to be the leaf skeleton block and draw around it onto the piece of card.

3 Cover the piece of card with a medium thick layer of PVA glue. Take a length of string and also coat this in the glue. Place the string onto the card following the outline of the leaf and pressing down with your fingers. (If the string isn't staying in place leave the glue to go a little tacky, then try again.)

4 Cut lengths of string and place them inside the leaf outline to build up the veins. (You may find it easier to draw lines onto the card to follow.)

5 Coat the whole block with more glue using an old paintbrush and a downward dabbing motion.

CONT. ⟩⟩⟩

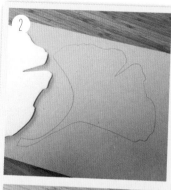

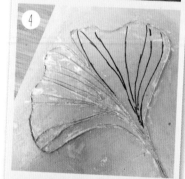

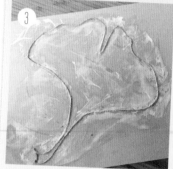

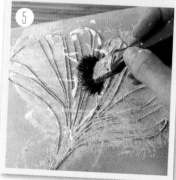

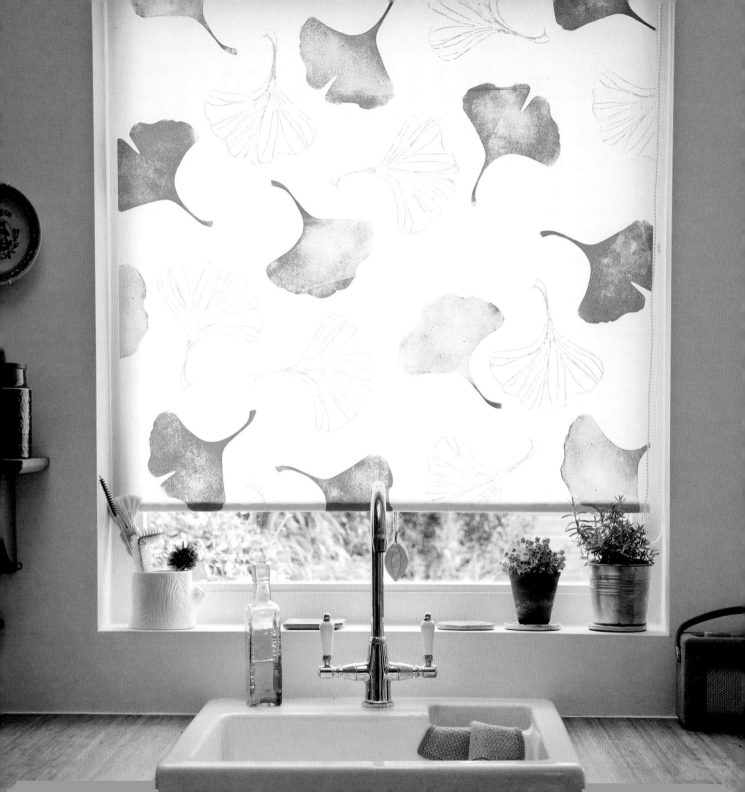

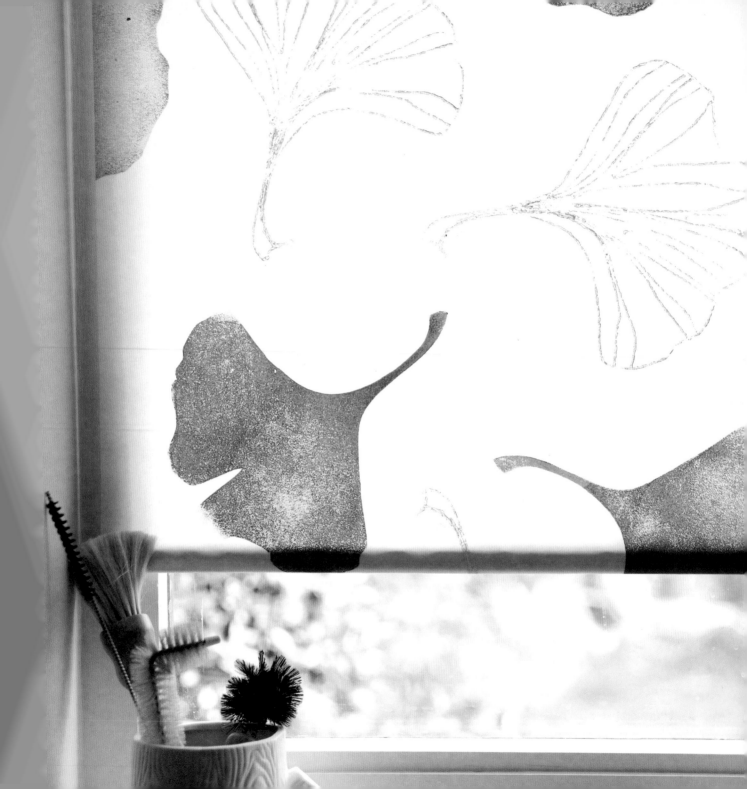

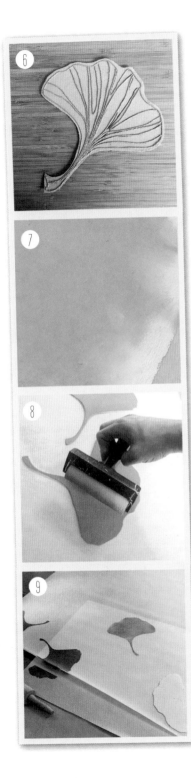

》》》

6 Leave the string block to dry, ideally overnight or at least until all the glue has gone clear. Cut away the excess card leaving the leaf shape.

TO PRINT ON THE BLIND

7 Print the solid green leaves first. Mix up a greeny yellow on the glass plate using 2 parts green and 1 part yellow. Roll out to a fine consistency (see page 15), but don't completely mix the colour together. For a more realistic look, it's better to leave the paint mix so it is a bit patchy.

8 Roll the ink onto the foam blocks, trying to keep the yellow part of the roller on the edge of the leaf.

9 Lay the blind out on a flat surface over a protective covering on your table. If you can lay out the whole length of the blind at once, so much the better. Starting at the bottom of the blind, begin printing the leaves. As you print each leaf, rotate them so they look like they are falling. Alternate the two leaf shapes and print some over the edges of the blind. Remember to leave space for the white skeleton leaf.

10 For the white skeleton leaf, squeeze out some white ink on the glass plate and roll out to a medium consistency. Ink up the block and make a couple of practice prints on some scraps of paper or fabric as the ink takes a while to soak into the string.

11 Print the white skeleton leaves in between the green ones, rotating them as before. Leave to dry overnight.

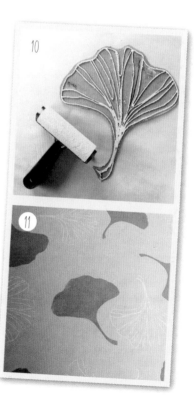

BLEACH BEACH TOWELS

These towels look so professional and the pattern so complicated it's hard to believe they are simply done with household bleach and a cookie cutter. Cutters of any shape can be used, and once you've got the hang of it you can make random or geometric patterns super quickly.

SUPPLIES

Towel, washed and ironed

Plastic sheeting

Heavy-duty masking tape or Gaffa tape

Rubber gloves

Thick household bleach

Glass, metal or ceramic flat-bottomed bowl

Cookie cutters in your chosen shape and size: for the blue towel I used a circular cutter. For the mauve towel I used a six-pointed star, and for the blue towel a triangle cutter (see the box on page 106)

BEFORE PRINTING ...

It is best to practise this technique with a flannel in the same towelling first so you get the hang of how drippy the bleach is and what colour the towel will turn when bleached.

TO PREPARE FOR PRINTING

1 Prepare your work area: bleach will not only strip out the colour from your towels, but also from any other fabric it touches, so make sure you're wearing old clothes and protect the area around you with plastic sheeting. I tend to do any bleach printing outdoors as it's less risky. Bleach doesn't strip the colour out straight away, so you won't notice the massive splash marks on your favourite cushion or tablecloth until it's too late!

2 Lay the towel in a landscape position on a protected flat surface – an old piece of wood slightly larger than the towel is good or a tabletop protected by plastic.

3 Tape the towel to the surface along all its sides. Try to just tape the bound selvedge of the towel and not the fluffy loops. Also cover with tape any part of the towel that you don't want bleached.

4 Put on the rubber gloves and pour bleach into the bowl to the depth of 1cm. Place the bowl near your towel and put the cookie cutter into the bleach.

CONT. >>>

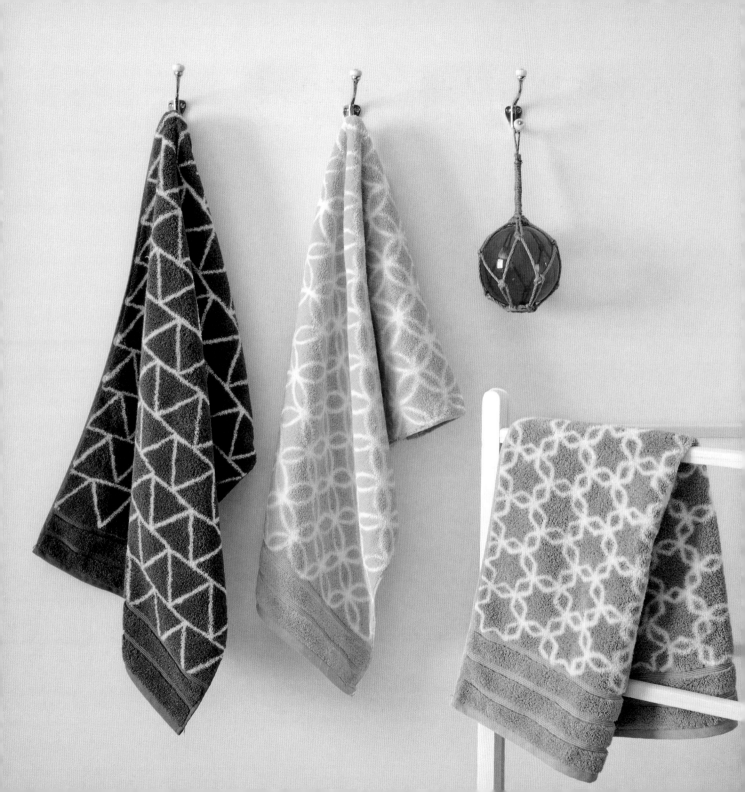

>>>

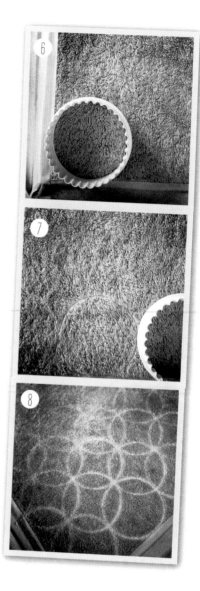

TO PRINT THE PATTERN

5 Lift out the cookie cutter and hold it above the bowl for 5 seconds to allow any excess bleach to drain off. Some shapes may create a film of bleach across the cutter, in which case pop this with a finger (mind your eyes If doing this project with children: get them to wear safety glasses).

6 Starting at the bottom left of the towel, place the cutter into position and press onto the towel as firmly as if you were cutting out a cookie.

7 Remove the cookie from the towel, dip it back in the bleach and repeat step 6 until the towel is covered.

8 You will notice the bleach develops over time – the longer you leave it, the paler the bleached areas will go. Wait until the towel is completely dry (and the bleach has done its work), then hand wash with a mild detergent. Hang the towel out to dry.

TO MAKE THE OTHER TWO TOWELS …

Prepare the towels as for steps 1–5, then print.

To print triangles on the blue towel
ROW 1: With the triangular cookie cutter, print one row of triangles along the bottom width of the towel.

ROW 2: Print another row of triangles directly above the first so the base of the second row touches the tip of the first. Repeat until finished and then follow step 8.

To print stars on the turquoise towel
ROW 1: With the star cookie cutter, print one row of stars with one star point at the top and one at the bottom. Make sure the adjacent stars touch each other.

ROW 2: Print the second row about the first, again making sure the lower points of the second row touch the upper points of the first. Repeat until finished and then follow step 8.

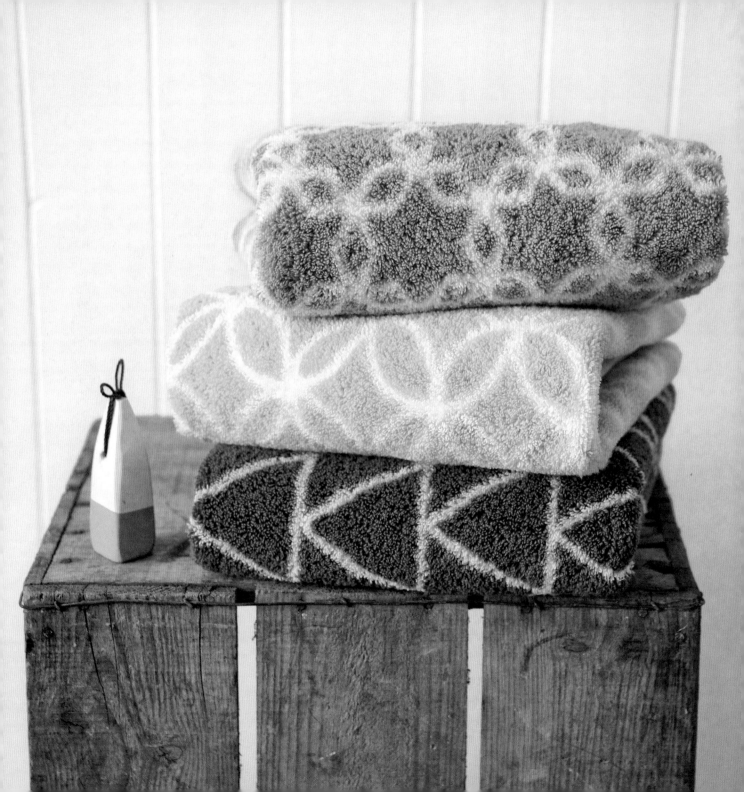

WHICH WAY? PENCIL CASE

This project is made from a product called Inkodye, which uses good old sunshine to make it work. You also need a shaped hole punch: I have used one shaped like an arrow, but there are many other shapes you could choose from.

SUPPLIES

Light coloured cotton pencil case

Arrow-shaped hole punch

Black paper

Inkodye pack

Glass plate

Sunshine

1 Wash the pencil case and allow it to dry completely. Use the hole punch to punch out 40 or so arrows from the black paper.

2 Place the case on a tray, then follow the instructions from the Inkodye kit and cover the front of the pencil case with the dye using the roller sponge that comes with the kit. Throw away any excess dye.

3 Scatter the arrow shapes over the pencil case, pressing each one down onto the ink to stay in place.

4 Put the glass over of the case and take it and the tray outside into the sunshine. You will see the ink change colour immediately.

5 After 20 minutes (or when you think the colour can't go any darker), bring the case indoors. Remove the black arrows to reveal the original colour of the case.

6 Repeat with the back of the case, if required, and then follow the kit instructions for washing and drying it, so it's all ready to be filled.

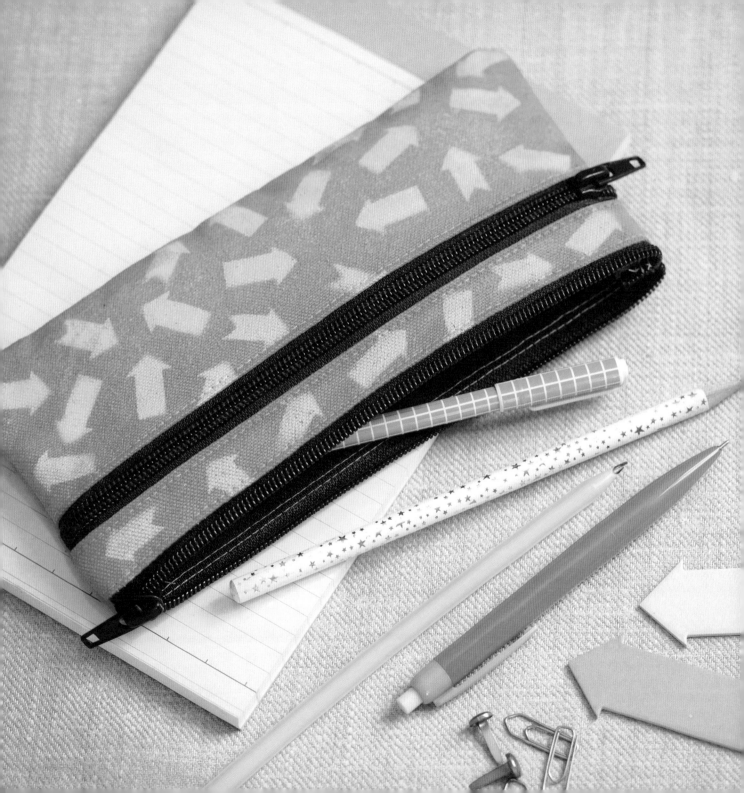

SUNFLOWER TABLECLOTH

★ ★

The big bountiful blooms of these sunflowers make a cheery print for a tablecloth or cushion. When making the printing block, the free running glue makes for a charmingly relaxed abstract print.

Thick card

Pen

Bottle of PVA glue with a nozzle top

Scissors or craft knife

Cutting mat (optional)

Round tablecloth in pale colour

Ochre, orange, yellow and green printing inks (see pages 12–13 for colour mixing tips)

Glass sheet

Roller

Rolling pin

TO PREPARE FOR PRINTING

1 Using the sunflower drawings below left for inspiration, draw a rough sunflower shape onto the card approximately 30cm in diameter.

2 Using the PVA bottle as the drawing tool squeeze glue through the nozzle following the sunflower shape. Aim for a consistent flow of glue around the flower (you can always fill in empty spaces later).

3 Complete the whole outline of the flower. If you aren't happy with the line, it is easy to wipe away with a damp cloth and try again until you get it right.

4 Repeat steps 1–3 to make two more flowers, each one a slightly different shape. Leave to dry, ideally overnight but at least until all the glue has gone clear. Cut out the flower around the glue with the scissors or craft knife, leaving about 3mm clear around the edge.

CONT. >>>

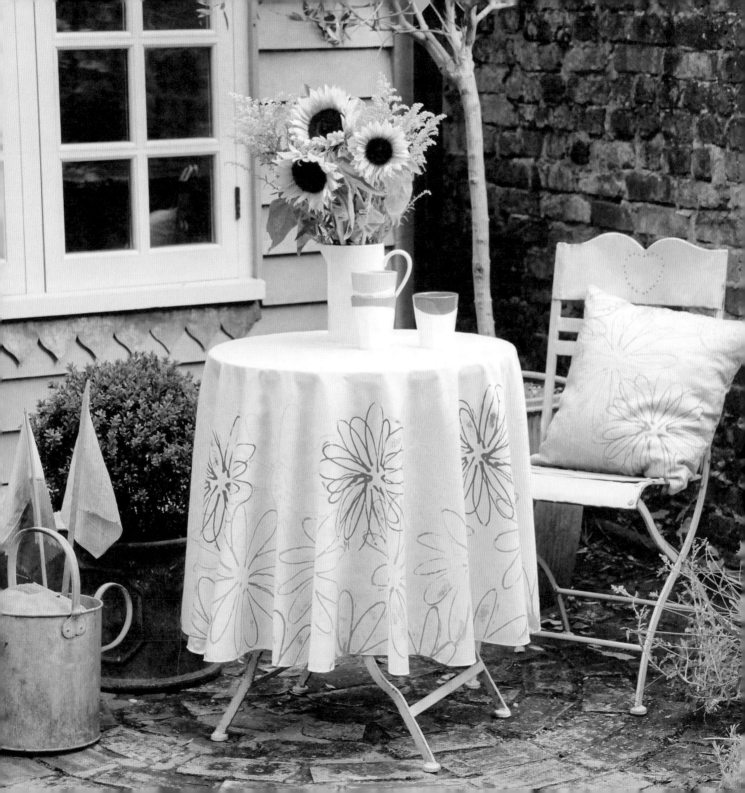

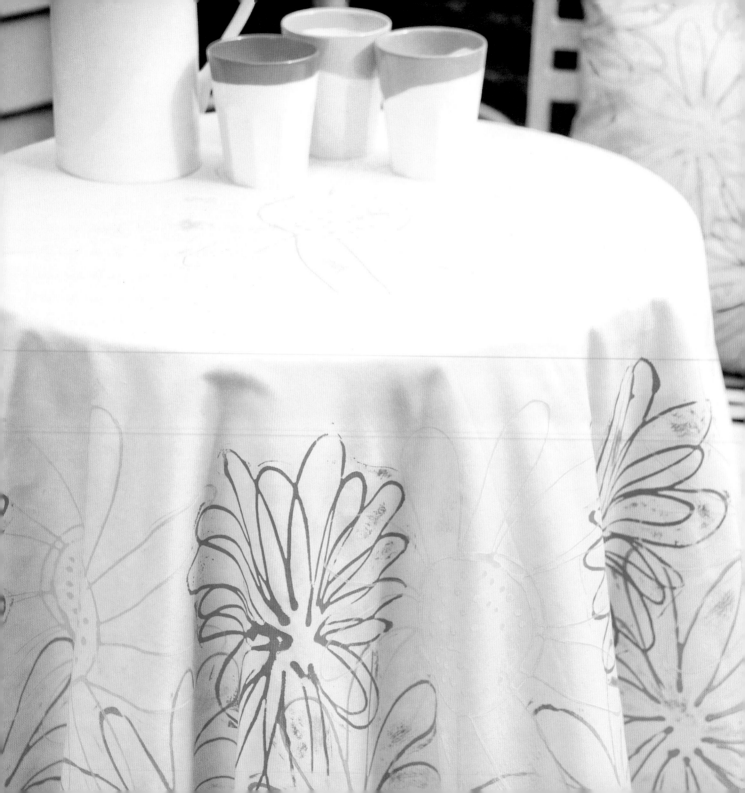

>>>

TO PRINT ON THE TABLECLOTH

5 Lay the tablecloth out onto a flat surface – a dining table or hard wood floor is ideal.

6 Mix up some ochre ink on the glass plate and roll it out to a medium consistency (see page 15). Then roll up one of the flowers. Clean away any excess ink on the block using a tissue (a little excess ink gives a nice texture to the print so don't worry if you don't get it all).

7 Place the flower block face down onto the tablecloth about 5cm up from the hem, press down and then use a clean rolling pin to apply pressure.

8 Carefully remove the block and re-ink it. Repeat step 7, moving the flower around the tablecloth and leaving about 10cm between each flower until you have completed the circle.

9 Repeat steps 6–8 with the second sunflower block and using orange ink. Place it between two ochre flowers so just the tips of the petals are touching the tops of the ochre flowers. Leave room between the orange flowers for the third flower.

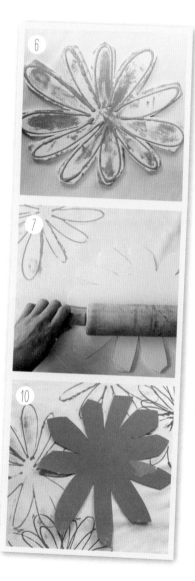

10 Repeat steps 6–8 with the third sunflower, printing this in yellow. Nestle it between the orange and ochre flowers.

11 Clean up the first flower and re-ink it with a green ink. Use this to print a border around the base of the tablecloth. Finally print one sunflower in the middle of the cloth. Leave to dry.

ALSO LOOKS GOOD ON ...

Duvet cover: these flowers printed in shades of one colour would liven up a dull bedroom. Either print all over the cover or just a band around the middle.

Cushion cover or bag: print either one big flower in the middle of a cushion cover or cover one completely in blooms.

Walls: a wall printed with oversize sunflowers would look amazing. Use pieces of A1 card to make the blocks. When it comes to the printing, it is easiest to have two people around when printing onto the wall – one to hold the block on the wall and the other to apply the pressure. Fun!

TEMPLATES

OWL FAMILY NOTEBOOKS
100%

OWL C
overprint

OWL A

OWL C
solid block

OWL B

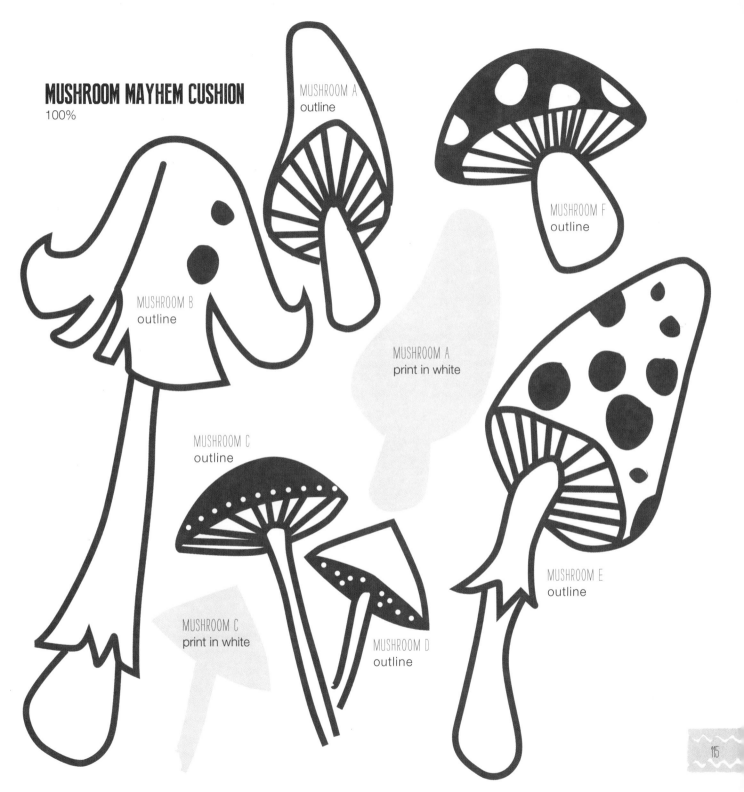

MUSHROOM MAYHEM CUSHION
100%

MUSHROOM A
outline

MUSHROOM F
outline

MUSHROOM B
outline

MUSHROOM A
print in white

MUSHROOM C
outline

MUSHROOM E
outline

MUSHROOM C
print in white

MUSHROOM D
outline

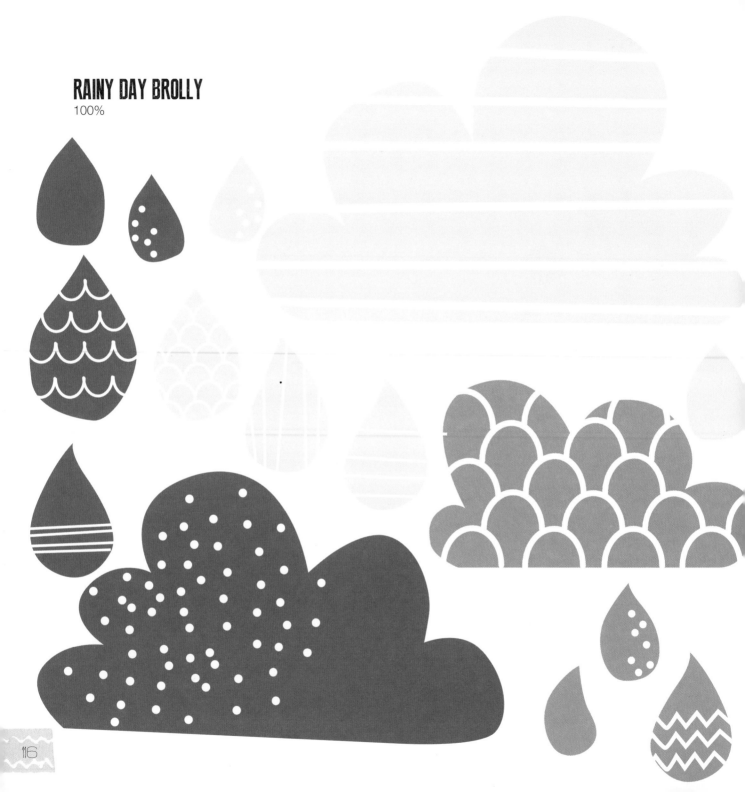

RAINY DAY BROLLY
100%

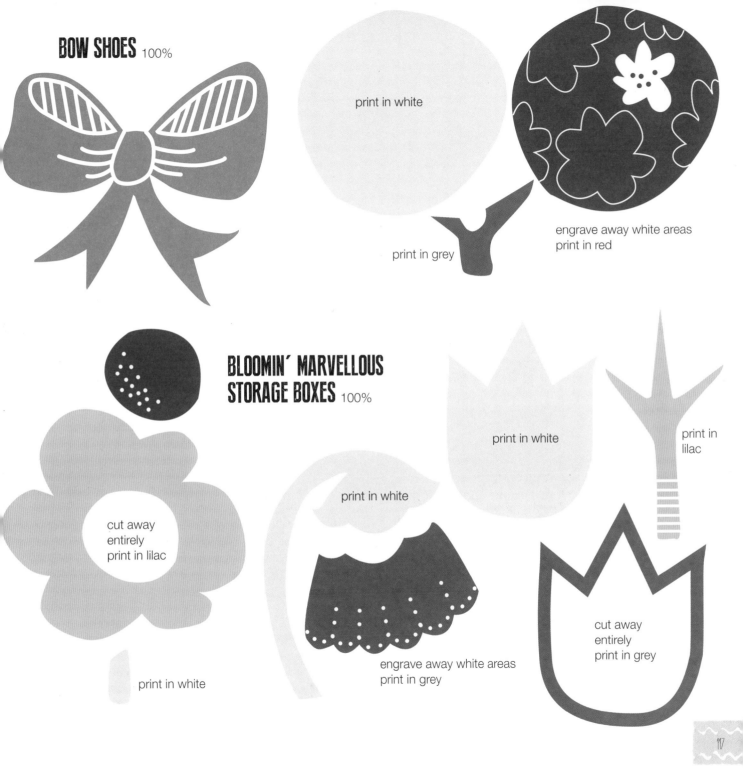

BOW SHOES 100%

print in white

print in grey

engrave away white areas
print in red

BLOOMIN' MARVELLOUS
STORAGE BOXES 100%

print in white

print in
lilac

cut away
entirely
print in lilac

print in white

print in white

engrave away white areas
print in grey

cut away
entirely
print in grey

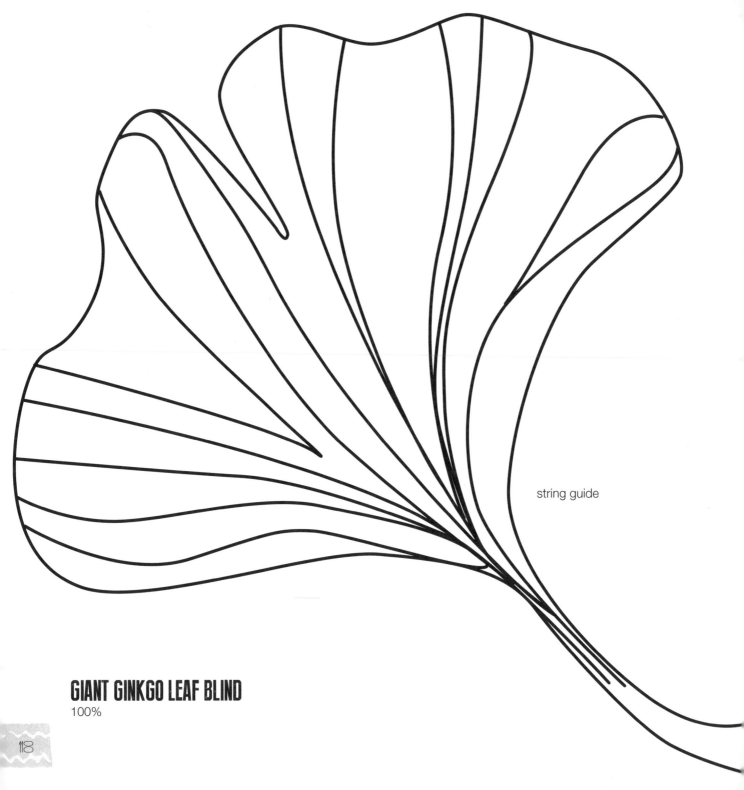

string guide

GIANT GINKGO LEAF BLIND
100%

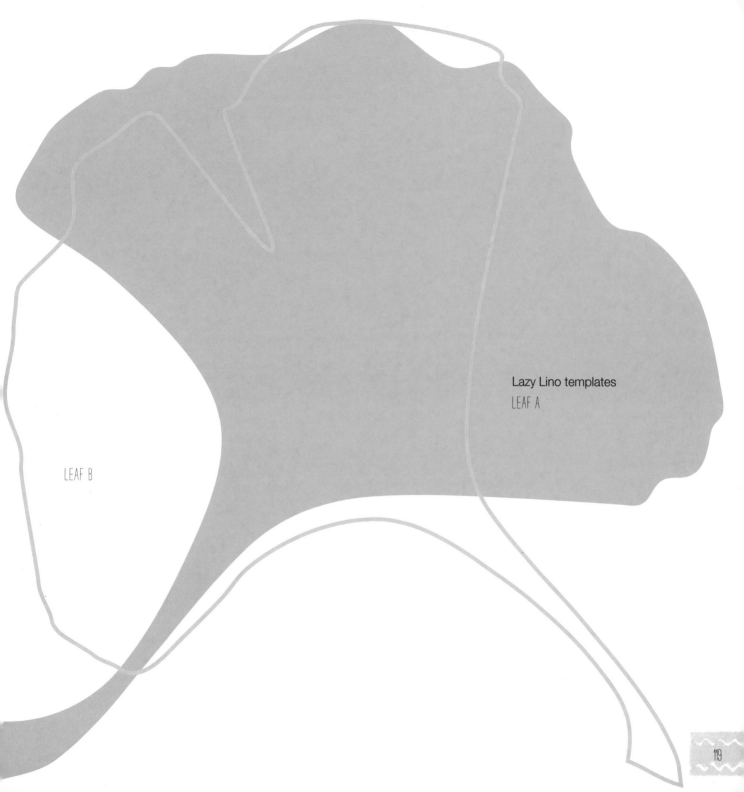

Lazy Lino templates
LEAF A

LEAF B

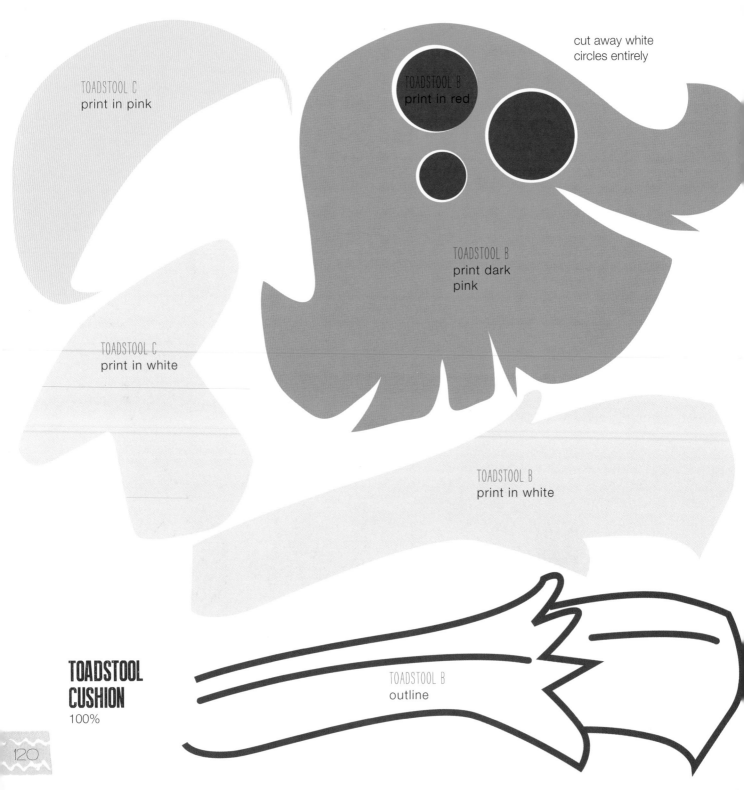

TOADSTOOL C
print in pink

cut away white
circles entirely

TOADSTOOL B
print in red

TOADSTOOL B
print dark
pink

TOADSTOOL C
print in white

TOADSTOOL B
print in white

TOADSTOOL B
outline

**TOADSTOOL
CUSHION**
100%

120

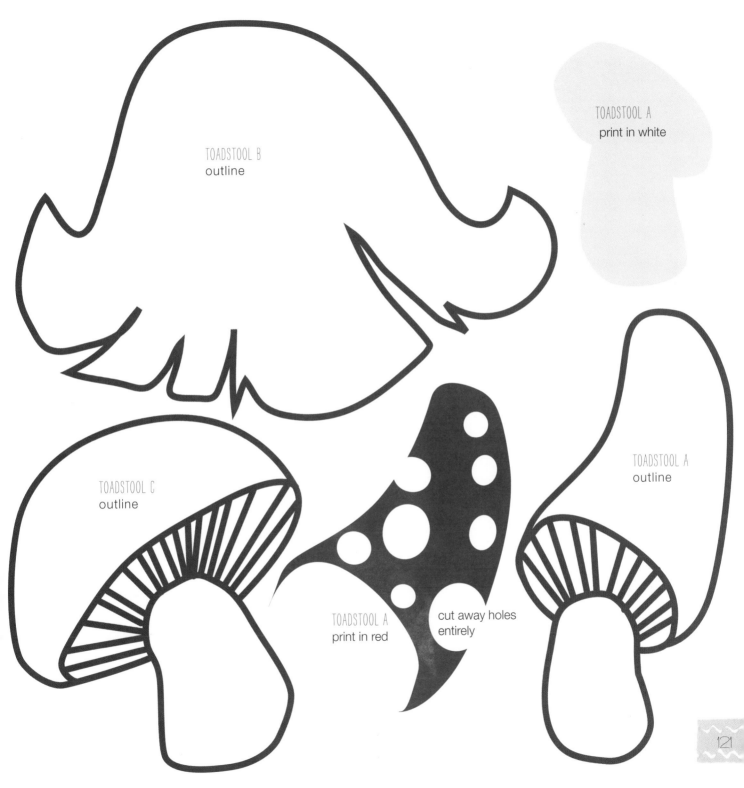

TOADSTOOL B
outline

TOADSTOOL A
print in white

TOADSTOOL C
outline

TOADSTOOL A
outline

TOADSTOOL A
print in red

cut away holes
entirely

MRS HARE

enlarge by 150% for T-shirt
and front of bag

100% for reverse of bag

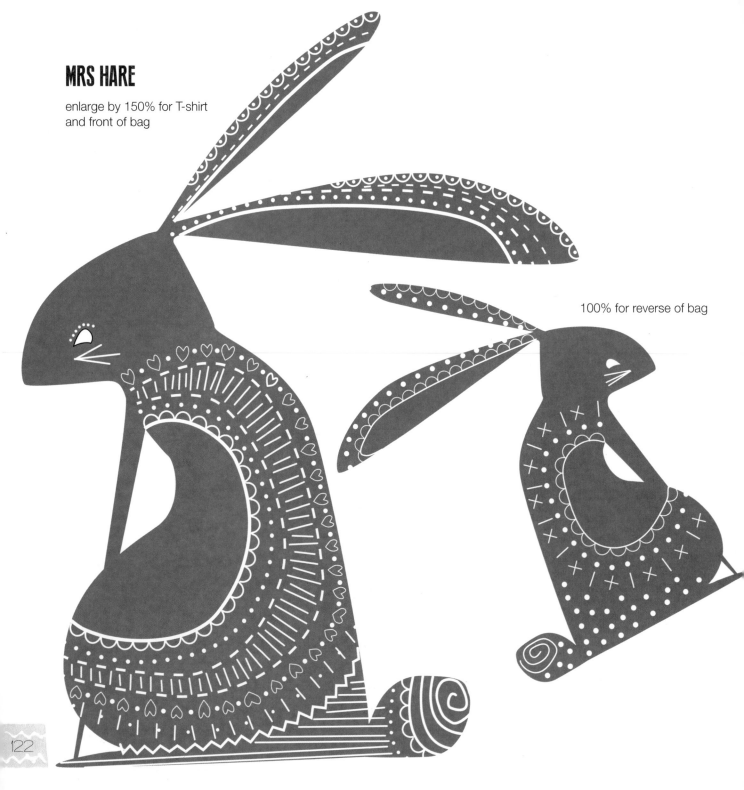

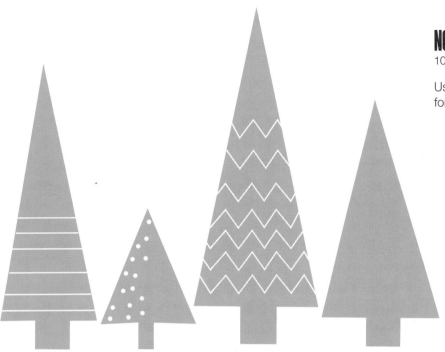

NORDIC FOREST LAMPSHADE

100%

Use trees on individual blocks
for printing on the Tote Bag

Tree set A 100%

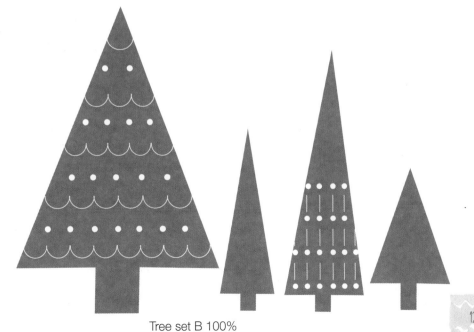

Tree set B 100%

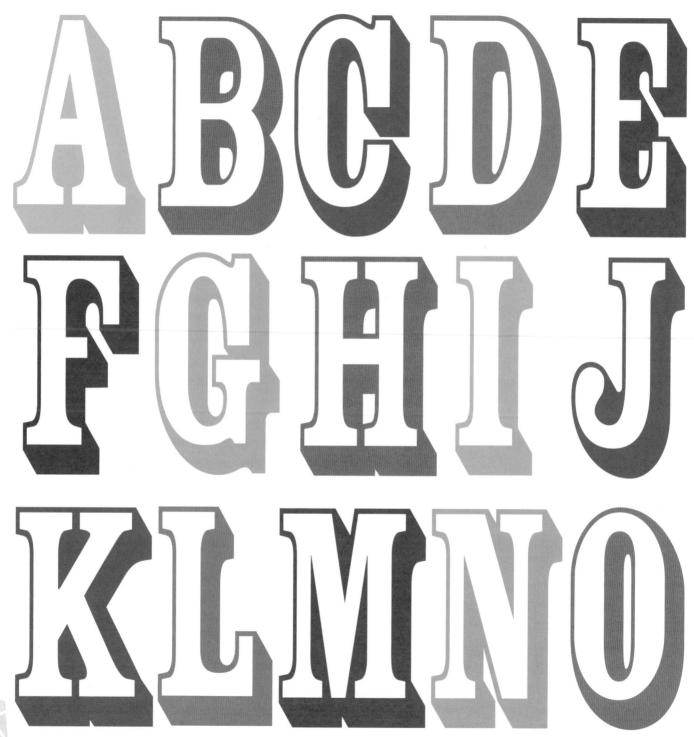

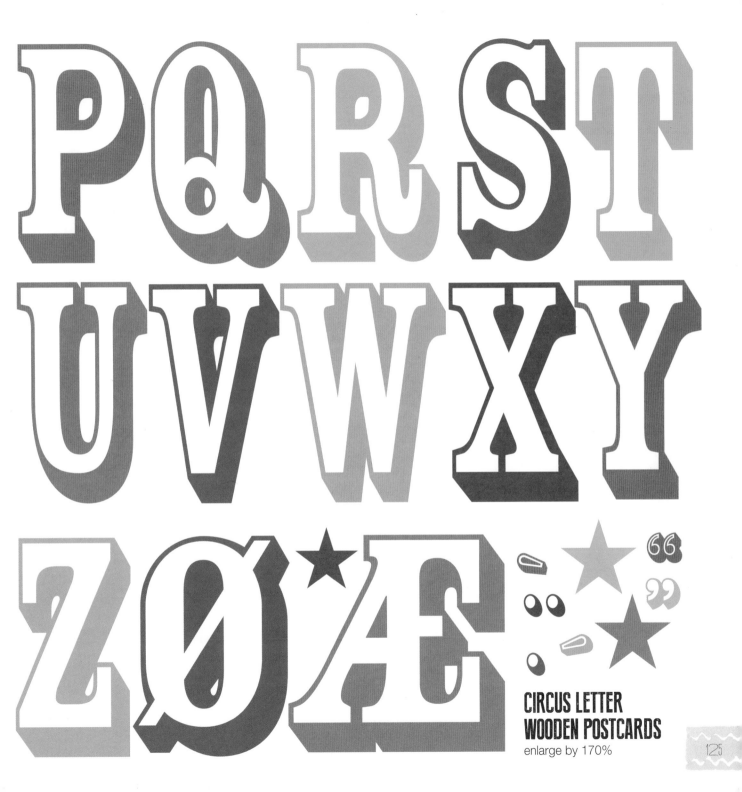

PQRST
UVWXY
ZØÆ ★

CIRCUS LETTER
WOODEN POSTCARDS
enlarge by 170%

RESOURCES

BROLLIES GALORE
www.brolliesgalore.co.uk
0845 602 3712
As the name suggests, this online brolly shop sells a rainbow array of coloured brollies.

THE CLEVER BAGGERS
www.thecleverbaggers.co.uk
01938 530 050
Tote bags, aprons and tea towels are just a few of the products this online store sell in a range of colours – all blank just waiting for your prints.

COWLING AND WILCOX
www.cowlingandwilcox.com
Large chain of art shops with five London stores.

HANDPRINTED
www.handprinted.net
01243 697606
This website is your one-stop shop for printing supplies. It sells everything you need for all kinds of printing. It also has several handy guides to printing to download and inspirational videos to watch.

HOBBYCRAFT
www.hobbycraft.co.uk
01202 596100
A nationwide chain of hobby and craft superstores.

LABOUR AND WAIT
www.labourandwait.co.uk
020 7729 6253
This is an East London homeware shop specialising in products with a beautiful utilitarian feel. Simple but gorgeous.

LAWRENCE
www.lawrence.co.uk
01273 260260
A Hove-based art shop with a great online store. Sells a range of printmaking goodies and the products range from entry level to beautifully made professional rollers and tools.

PAPERCHASE
www.paperchase.co.uk
The London flagship store on Tottenham Court Road has a good art supplies section and a whole host of papers for print experiments. Check out their website for stores in other towns.

SPEEDBALL ART
www.speedballart.com
Manufacturers of printing supplies and inks, which can be found in all good art shops. Their website is full of helpful information on their products including a FAQ section where you can post any queries you have about a product or process.

ITEMS TO PRINT ON
Check out these places for a good range of plain T-shirts, shoes, lampshades, cushion covers and towels just waiting to be printed on. Go to their website to find your nearest store:
www.BHS.co.uk
www.ikea.com/gb/
www.matalan.co.uk
www.primark.co.uk
www.tigerstores.co.uk

FREE ONLINE FONTS
There are lots of websites with free fonts to download. Try:
www.dafont.com
www.fontsquirrel.com

INDEX

atomic kitchen tea towels 26–9

bags: Mrs Hare and family tote
 74–6, 122
 Nordic forest 68–9, 123
bleach beach towels 104–7
blinds, giant ginkgo leaf 100–3,
 118–19
bloomin' marvellous storage boxes
 86–9, 117
boots, button 34–5
botanical greetings cards 22–5
bow shoes 62–3, 117
boxes, bloomin' marvellous storage
 86–9, 117
brolly, rainy day 90–3, 116
bunting, delicate doily 42–5
button boots 34–5

cards, botanical greetings 22–5
circus letter wooden postcards
 94–7, 124–5
clothing: Haiwatha T-shirt 40–1
 Mrs Hare T-shirt 77, 122
colour mixing 12–13
cushions: feather 36–9
 knitty natty 52–5
 mushroom mayhem 78–81, 115
 toadstool 82–5, 120–1

doily bunting 42–5

equipment 8–11

feathers: botanical greetings cards
 22–5
 feather cushion 36–9
found objects, printing with 20–59

giftwrap, glittery 30–3
ginkgo leaf blind, giant 100–3,
 118–19

Haiwatha T-shirt 40–1

indentations, making 14
inks 9, 12–13, 15

knitty natty cushion 52–5

lacey casey 46–7
lampshade, Nordic forest 64–7, 123
lazy lino 10
 prints 60–97
 templates 16–19
leaves: botanical greetings cards
 22–5
 giant ginkgo leaf blind 100–3,
 118–19
letters, circus letter wooden
postcards 94–7, 124–5

Mrs Hare and family tote bag 74–6,
 122
Mrs Hare T-shirt 77, 122
mushroom mayhem cushion 78–81,
 115

napkins, shimmering scales 56–9
Nordic forest bag 68–9, 123
Nordic forest lampshade 64–7, 123
notebooks, owl family 70–3, 114

objects, printing with found 20–59
owl family notebooks 70–3, 114

patterns, transferring 14
pencil case, which way? 108–9
pillows, lacey casey 46–7
postcards, circus letter wooden
 94–7, 124–5

rainy day brolly 90–3, 116
ric rac scarf 48–51

safeprint foam 10, 16–19, 60–97
scarves, ric rac 48–51
shimmering scales napkins 56–9
shoes: bow shoes 62–3, 117
 button boots 34–5
storage boxes, bloomin' marvellous
 86–9, 117
sunflower tablecloth 110–13

T-shirts: Haiwatha 40–1
 Mrs Hare 77, 122
tablecloth, sunflower 110–13
tea towels, atomic kitchen tea
 towels 26–9
templates 114–15
toadstool cushion 82–5, 120–1
tote bag, Mrs Hare and family 74–6,
 122
towels, beach bleach 104–7

umbrella, rainy day 90–3, 116

which way? pencil case 108–9

THANK YOU THANK YOU THANK YOU

Thanks to all at Quadrille:
Lisa for accepting my million half-cocked emails without a murmur, and Gemma for making the book look ace. Thank you to Emma for making sure everything is spelt right and makes sense. To lovely Keiko for the beautifulness and to Chinh for looking so pretty.

Thank you to Miss Jones, who may or may not have come up with the book's title.

Thank you, too, to Speedball Art for supplying the inks and rollers for the book.

To all my family: Mum and Dad for their general brilliance, patience and tidying skills; Jo, Ian and the boys for their ideas and support; Aunty and Uncle; and Nanny and Grandad for their support, belief, encouragement and suggestions.

Love to Jake, Kirsty (and Daisy now), Laura, and everyone who has to hear about 'the book', even though half of you don't know which one I'm talking about now!

Publishing Director Jane O'Shea
Commissioning Editor Lisa Pendreigh
Editor Emma Callery
Creative Director Helen Lewis
Art Direction & Design Claire Peters
Designer Gemma Hogan
Photographer Keiko Oikawa
Stylist and Illustrator Christine Leech
Production Director Vincent Smith
Production Controller Aysun Hughes

Quadrille
craft

www.quadrillecraft.com

First published in 2014 by
Quadrille Publishing Ltd
Alhambra House
27–31 Charing Cross Road
London WC2H 0LS
www.quadrille.co.uk

Text, project designs, artwork & illustrations
© 2014 Christine Leech
Photography
© 2014 Keiko Oikawa
Design & layout
© 2014 Quadrille Publishing Ltd

The designs in this book are copyright and must not be made for resale.

British Library Cataloguing-in-Publication Data. A catalogue record for this book is available from the British Library.

ISBN: 978 184949 464 9

Printed in China.